IMAGES
of America

MARITIME
ELIZABETH CITY

D1452280

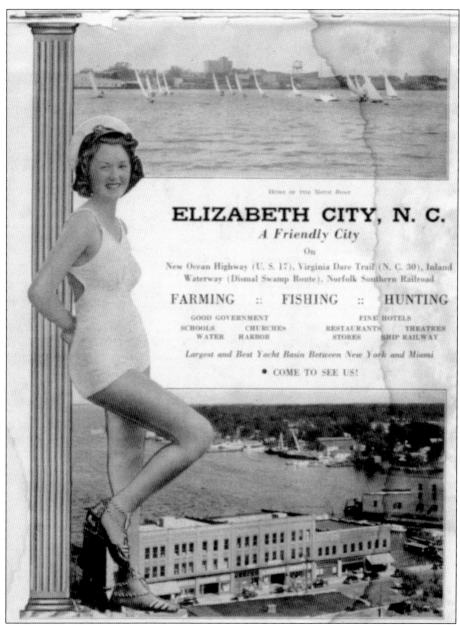

This promotional poster advertising Elizabeth City as both an attractive, rural, Southern town and a thriving maritime tourist destination dates to around 1940. Depicted here are two views of the Elizabeth City waterfront overlooking the Pasquotank River. The girl posing at left is Elizabeth City native and champion Moth boat sailor Violet Cohoon. (Museum of the Albemarle, North Carolina Department of Natural and Cultural Resources.)

ON THE COVER: Spectators watch the annual Moth Boat Regatta on the Pasquotank River in this image captured around 1951 by Elizabeth City photographer John E. "Jack" Williams. (Museum of the Albemarle, North Carolina Department of Natural and Cultural Resources.)

IMAGES
of America

MARITIME
ELIZABETH CITY

Paul M. Vincent
Foreword by Don Pendergraft

ARCADIA
PUBLISHING

Published by Arcadia Publishing
Charleston, South Carolina

Printed in the United States of America

Library of Congress Control Number: 2022933243

For all general information, please contact Arcadia Publishing:
Telephone 843-853-2070
Fax 843-853-0044
E-mail sales@arcadiapublishing.com
For customer service and orders:
Toll-Free 1-888-313-2665

Visit us on the Internet at www.arcadiapublishing.com

Dedicated to the late George S. Converse, lieutenant colonel (USMC) and former Museum of the Albemarle volunteer, whose invaluable historical research on the Elizabeth City Shipyard–built US Navy subchasers will not be forgotten

CONTENTS

FOREWORD

In researching the Museum of the Albemarle's extensive photographic collection for this Arcadia title, author Paul Vincent has crafted a detailed maritime history, rich in modern boatbuilding, of Elizabeth City—the gateway to the Albemarle region.

The history of the people living in this area dates to 10,000 BCE. The Algonquin people mastered their environment, establishing villages, farms, hunting as well as fishing grounds, and a coastal trade network stretching from Labrador, off the coast of Canada, to Guatemala, in Central America. These Indigenous tribes were mariners who knew how to travel most efficiently on the water to avoid the soggy marshland, swamps, and the impassable trails with thick vegetation.

European settlers adapted the native people's skill of boatbuilding, carving and shaping their hulls with metal tools rather than with fire as well as adding sails for propulsion. The early English and French colonists used such techniques to construct the *Periauger*, a Colonial-era workboat and distant relative of the split-hull canoe. These vessels were the beginnings of a unique style of boat able to navigate the shallow waters of the Albemarle Sound. This style of boat was classified as the Albemarle seine boat. The *Alvirah Wright* shad boat, displayed in the museum lobby, is an excellent example of the regional developments in boats from northeastern North Carolina. These boats earned a reputation for being nimble, rugged, and slick fast on the waters surrounding Elizabeth City.

The boats pictured in *Maritime Elizabeth City* are evidence of the many varieties of watercraft that trace their lineage back to those traditional styles and showcase the inventive spirit of the people of this region.

The Museum of the Albemarle is a great place to discover the past, preserving and interpreting the history of Elizabeth City as well as northeastern North Carolina for future generations.

I invite you to visit and enjoy an adventure through the maritime history of this Albemarle region.

—Don Pendergraft
Director of Regional Museums, North Carolina Museum Division
North Carolina Department of Natural and Cultural Resources

ACKNOWLEDGMENTS

Special thanks to Wayne Mathews, Lynette Sawyer, and Visit Elizabeth City for their help with supplying a few good snapshots for this title. Thanks also to Carrie Barker, Marjorie Berry, and Wanda Lassiter for their keen editorial assistance. A big thank-you to the whole Museum of the Albemarle staff for their kind words and welcomed advice throughout the production of this book. My sincere appreciation goes to editor Caitrin Cunningham for her indispensable support and service to seeing this project accomplished. Thank you to all those who have donated to the Museum of the Albemarle in allowing the use of your treasures to make this album possible.

Unless otherwise noted, all photographs are courtesy of the Museum of the Albemarle, North Carolina Department of Natural and Cultural Resources.

"Harbor of Hospitality" is a registered trademark of Visit Elizabeth City.

INTRODUCTION

The Albemarle region of North Carolina is often described of as being half water and half land. The former half of this domain is embodied in the Albemarle Sound and the handful of river systems that have come to shape both the society and culture of the Old North State's northeasternmost counties. The people of Elizabeth City, who are profoundly molded by this unique regional geography, have relied for generations on the water for their livelihoods and enjoyment.

From the very outset, centuries prior to the Europeans' arrival in what would eventually become Elizabeth City, the first inhabitants here greatly benefited from the surrounding expanse of inland waterways. The Pasputonk, or Pasquotank, Indians, whose settlements were closest in proximity to the city's present-day boundaries, developed their own customs and rituals in relation to the bodies of water they lived near and around.

The very name Pasquotank, a derivative from the Algonquin Pasketanki, means where the current or stream divides or forks. Living and working close along the shores of the river, the Pasquotank as well as other Weapemeoc tribes took to fishing, in addition to farming and hunting, for sustenance. Using nets and hooks, they caught local freshwater species such as trout and perch as well as shellfish like mussels and clams. They also navigated these tributaries using dugout canoes as a means of ferrying themselves about their homelands.

As the Spanish and, later, English arrived off the North Carolina coast during the 16th century, they would ply these same waterways on their expeditions into the interiors of this uncharted territory. Exploration soon gave way to settlement, and the colonies of men, women, and children who voyaged here adopted many of the same maritime practices that no doubt benefited their native counterparts. With the first English settlers to this area, the waters of the Albemarle would offer ample opportunity for those making their way in the New World.

In 1663, King Charles II of England bestowed upon eight of his closest supporters a great tract of land encompassing nearly all of present-day North Carolina. The most northeastern portion of this new province of Carolina was named Albemarle County, for George Monck, the duke of Albemarle. It was also around this time that Thomas Relfe, one of the earliest settlers to the area, was granted 750 acres of land near which the current county seat of Elizabeth City is now located.

The Albemarle territory was divided further in 1668, with Pasquotank being one of four newly formed precincts. Its waters no doubt played a contributing role to the precinct's growth as an important political and geographical authority during this time. The first governmental assembly convened at Halls Creek, on the north end of Little River, in 1665. Summoned by then governor William Drummond, the Grand Assembly of the Albemarle met by its shores in February that year. Symond's Creek, in southwest Pasquotank County, was the site near which the first known school in North Carolina stood. Anglican lay reader Charles Griffin arrived in the province in 1705 and began teaching local children there by the following year.

Pasquotank County's political, social, and economic developments, bolstered by strong maritime traditions, expanded more so throughout the 18th century. Private landings, constructed along

the shores of the rivers and creeks, helped facilitate the shipping and trading of goods as water-based transportation was the norm. Colonial-era inspection stations like River Bridge, today an underwater archeological site, north of the city, on the Pasquotank River, formed a larger maritime network of commerce within the Albemarle region.

In 1764, such an inspection station was designated for a landing at "the Narrows" of the Pasquotank River; this promising waterfront locale would, in time, come to be known as Elizabeth City. An initial fledgling community gradually grew from the site over the next quarter century, then a substantial infrastructure initiative would steadily elevate its position within the region through the coming decades.

Begun in 1793, the Dismal Swamp Canal, once completed, would serve as a vital economic maritime artery between the Pasquotank River and the Elizabeth River, in neighboring Virginia. The small crossroads at the Narrows was made the southern post of this canal system, further enhancing its overall prospects. Incorporated as the town of Redding that same year, it was later known as Elizabethtown when made the governmental seat of Pasquotank County in 1799. Not until 1801 was the town's name finally changed to Elizabeth City.

Federal improvements to the Dismal Swamp Canal during the second quarter of the 19th century yielded further economic success for Elizabeth City. The waterway's enlarged dimensions could now accommodate vessels of greater tonnage and with this increased traffic came additional profitability. In 1827, the district customs house, previously headquartered in Camden County, removed to Elizabeth City, broadening the commercial viability of the town and its port as a locus of maritime activity.

However, these gains enjoyed during the antebellum years quickly faded as the scourge of war, starting in 1861, badly hampered the city's progressive outlook. A sharp decrease in canal travel, due in part to both the war and the competing Albemarle-Chesapeake Canal, negatively affected local merchants. The Battle of Elizabeth City, fought in February 1862, saw Union naval forces beleaguer and decimate an outmatched Confederate mosquito fleet; in the wake of fighting, the Pasquotank County courthouse was reduced to ashes. Elizabeth City fell into an economic depression following the war as the once lucrative canal through the Great Dismal Swamp was left to deteriorate over the next decade.

The city's fortunes would slowly begin to turn with the assistance of enterprising merchants and industrialists during the 1870s and 1880s. The arrival of Northern families, establishing their business interests in Elizabeth City, helped to revitalize the town's postwar socioeconomic condition. The Kramers, the Robinsons, and the Blades, for instance, all setup sawmill operations along the Pasquotank riverfront, manufacturing general and specialty building supplies, thereby spurring a robust lumber industry in town.

A slew of additional industries and businesses would go on to foster Elizabeth City's rise to prominence within northeastern North Carolina by the late 19th century. The introduction of the railroad, for one, in 1881 was no doubt a great boon to the city. Several marine railway and shipbuilding outfits began to dot the riverside around 1900. The local lumber mills produced barrels, boxes, crates, and trays for the vast quantities of seafood packed and shipped out from the city's many fish and oyster houses. Steamboat services regularly ferried passengers and cargo around the Albemarle region's sounds and rivers.

It is at about this time, at the beginning of the 20th century, that *Maritime Elizabeth City* picks up and elaborates on the Harbor of Hospitality's modern history. The multitude of period photographs and negatives, depicted alongside vintage postcards and source documents, are culled from the Museum of the Albemarle's own archival collections. These images highlight the past century of Elizabeth City's continued growth as an industrial and commercial port along the Pasquotank River as well as mark the city's transition to a travel destination and center of tourism in the 21st century. Above all, this album helps to illustrate the continuing story of a proud regional North Carolina people and their relationship with the water.

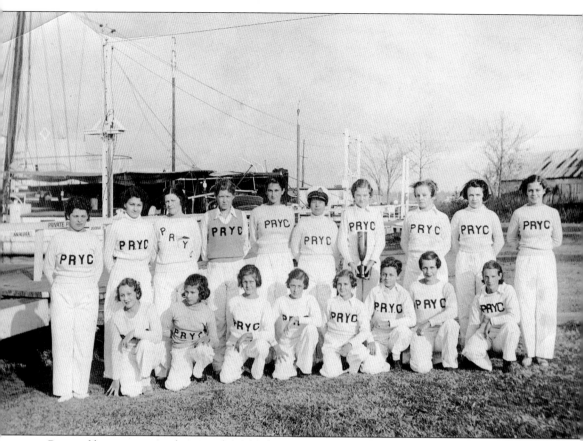

Pictured here is a group photograph of the Pasquotank River Yacht Club's girls' sailing team from 1934. From left to right are (first row) Dora Evans, Carol Vanture, Doris Payne, Miriam Jones, June Midgett, Mary Hopkins, Catherine Hathaway, and Ann Wilcox; (second row) Louise Willey, Barbara Hite, Susie Willey, Helen Hill, Sarah Payne, Millicent Sanders, Ruth Reid, Esle Hobbs, Margaret Lassiter, and Doris Gard.

One

ELIZABETH CITY
WATERFRONT

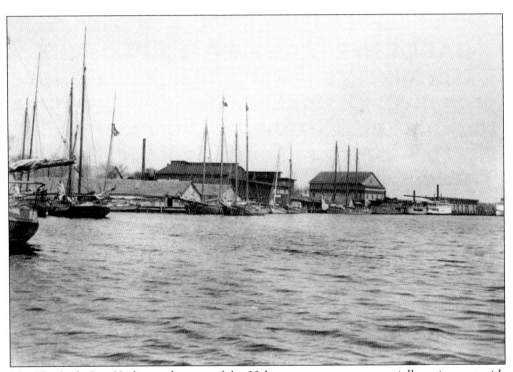

The Elizabeth City Harbor at the turn of the 20th century was a commercially active port with several businesses lining the Pasquotank River. This image shows some of those waterfront businesses north of Poindexter Creek. The large, central building in this photograph belonged to the Crystal Ice and Coal Company; the building to its right was the storage warehouse for the Norfolk & Southern Railroad.

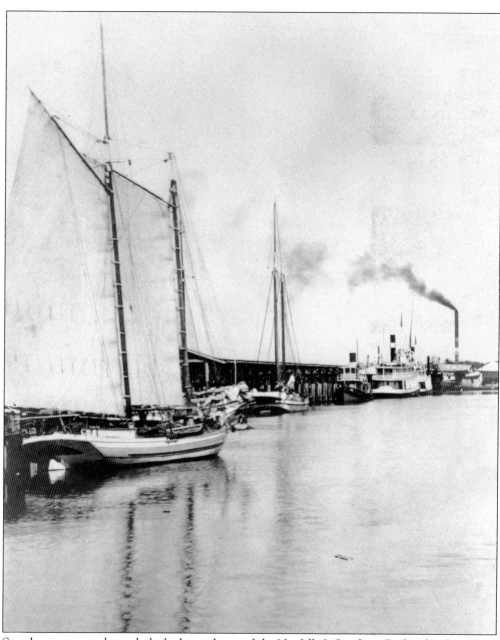

Seen here are several vessels docked at and around the Norfolk & Southern Railroad's wharf shed. The Norfolk & Southern Railroad established rail lines through northeastern North Carolina starting in the early 1880s. The railroad also operated a steamboat service line out of Elizabeth City, plying routes through all the major rivers and tributaries on the Albemarle Sound. The advent of both modern rail and steamer service to towns like Elizabeth City revolutionized transportation in the region as Norfolk & Southern offered North Carolinians faster, more reliable modes of travel. Farther behind this wharf, in the background, is the Foreman-Blades Lumber Company. Incorporated in 1906, this company became one of the most successful lumber operations in eastern North Carolina. Much of the lumber sent here to be processed and finished was eventually shipped to northern markets via the Norfolk & Southern rail line.

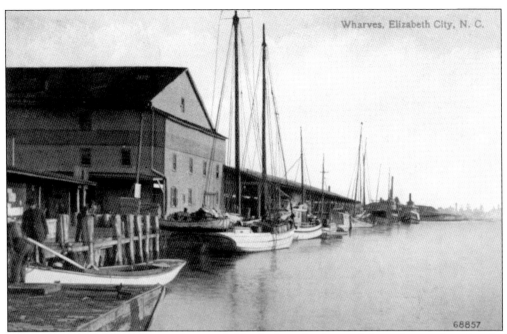

68857

In addition to finished lumber, other goods like fresh seafood passed through waterfront locales like Norfolk & Southern Railroad's wharf to be shipped out across the country. A 1901 figure in the *Weekly Economist* estimated the previous year's catch to be some 34,500 boxes, barrels, and cases worth of fish, including oysters and clams, processed in Elizabeth City's seafood houses. The industry contributed to well over $330,000 in annual revenue for the local economy.

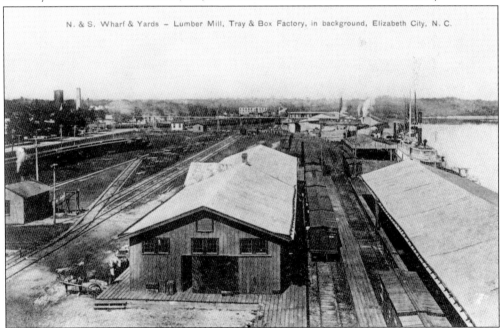

N. & S. Wharf & Yards – Lumber Mill, Tray & Box Factory, in background, Elizabeth City, N. C.

This image shows the rail lines that sat immediately behind Norfolk & Southern Railroad's waterfront wharf. The freight shed is in the far-right foreground. The street seen at the far left of the photograph is Pennsylvania Avenue, which is North Poindexter Street today.

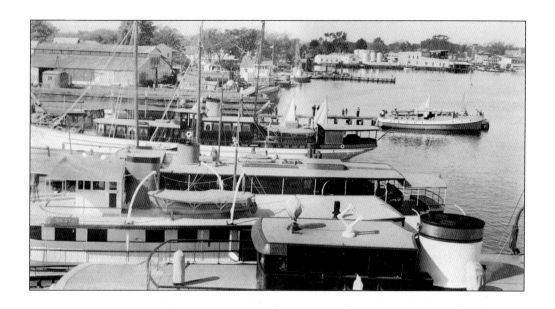

These photographs of the Elizabeth City Shipyard and yacht basin date from the early to mid-1930s. In the image above, the yacht *Siesta*, commanded by Capt. Joel Van Sant, can be seen in the foreground. In the background is the bell tower of Christ Episcopal Church, built around 1856 and one of the more distinctive landmarks seen from the river. The image below shows a broader view of the Elizabeth City skyline, including the Virginia Dare Hotel, city water tower, and W.H. Weatherly and Company building. The modern development of the harbor around this time saw the city's older, wooden structures like its oyster houses and marine railways gradually replaced with larger brick buildings lining the waterfront.

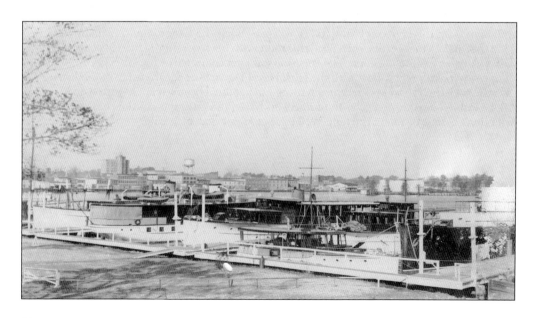

This view of the yacht basin was taken looking south-southeast towards present-day Riverside Avenue and Calvary Baptist Church. Originally Calvary Mission Chapel, the initial structure, erected on the site in 1899, housed Sunday school classes for the First Baptist Church. In April 1921, nineteen charter members helped organize Calvary Baptist Church with Rev. Romulus F. Hall as its pastor. After nearly 30 years of regular weekly services, a fire consumed the chapel on the morning of April 29, 1949, destroying the building and all its contents. However, construction on a new chapel began later that year under the leadership of longtime congregant Samuel S. Davis and Rev. Carl E. Bjork. The church enjoyed another 60 some years of fellowship and devotional service before its congregation finally disbanded. The building on Riverside Avenue still stands today, currently occupied by Harbor Presbyterian Church.

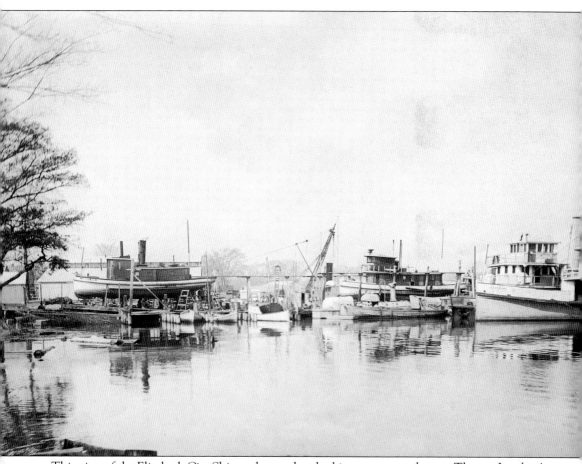

This view of the Elizabeth City Shipyard was taken looking west toward town. The tug *Lambert's Point*, at left, was part of the Lambert's Point Tow Boat Company fleet out of Lambert's Point in Norfolk, Virginia. The large metal building behind the tug is the Elizabeth City Iron Works and Supply Company's machine shop, which was built around 1920 and still stands today. The vessel to the right of the *Lambert's Point* is the harbor tug *Gen. J.M. Brannan*. Built in 1908 and named for Brig. Gen. John M. Brannan, the tug served with the US Army Coast Artillery Corps as a junior mine planter. At the time this photograph was taken, the *Brannan* had been transferred to the Corps of Engineers at Savannah Harbor in Georgia. The vessel at the far right is the *Hertford*, which, prior to her 1903 sinking, once served the Albemarle Steam Navigation Company as the *Olive*.

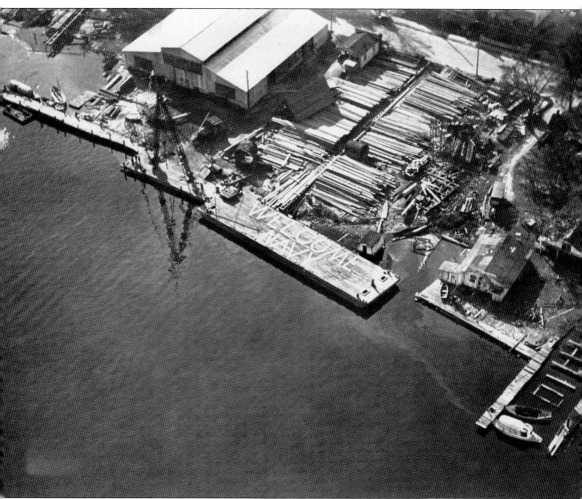

The long-standing relationship between Elizabeth City and the US Navy carries with it an incredible history deserving of recognition. Some of this storied past includes the Elizabeth City Shipyard's construction of several Navy patrol and work vessels during the Second World War. Starting in 1941 and working under government contract, the shipyard built thirty 110-foot, wooden-hulled subchasers. Several of these subchasers were transferred overseas to serve allied nations such as France and the Soviet Union in support of the war effort. The shipyard also received contracts to build four 110-foot harbor tugs. A wartime labor force of over 800 workers meant employing many of the townsfolk here as well. In addition to the construction of new Navy vessels, many more were brought to Elizabeth City for routine maintenance and repairs. The Elizabeth City Shipyard and its workers did a great deal to assist and supply the US Navy, and their efforts ought not to be forgotten.

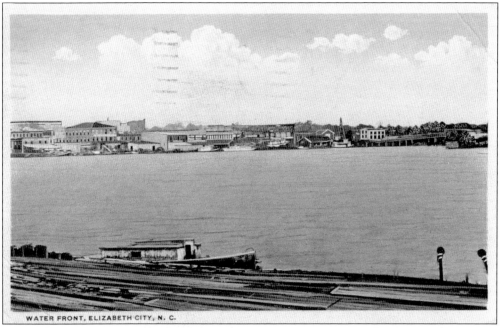

WATER FRONT, ELIZABETH CITY, N. C.

This picturesque postcard view of the Elizabeth City Harbor dates from around the early 1920s and is seen from the vantage point of one of the many shipyards along Riverside Avenue. The bridge spanning the Pasquotank River into Camden County is in the far-right background.

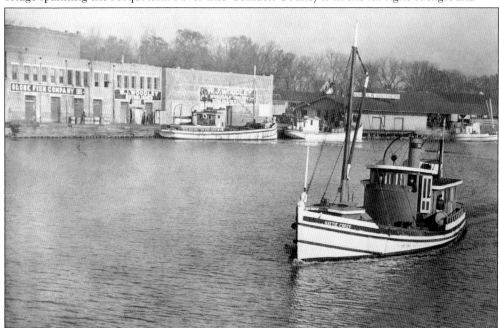

Here, the *Hattie Creef* plies the Elizabeth City waterfront by some of the businesses near North Water and East Burgess Streets. The *Hattie Creef* served the Globe Fish Company at the time this photograph was taken, around 1934, making regularly scheduled passage to and from Roanoke Island. The Norfolk & Southern Railroad's wharf shed can be seen in the right background though the earlier adjacent freight warehouse no longer stands.

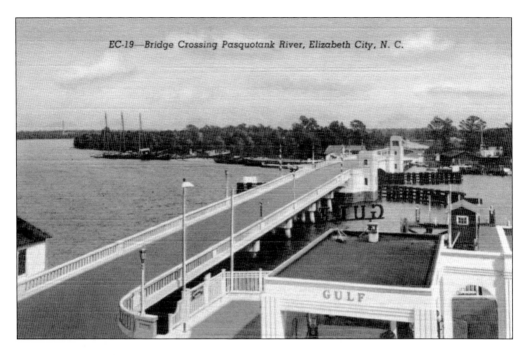

EC-19—Bridge Crossing Pasquotank River, Elizabeth City, N. C.

These views depict the Pasquotank River Bridge, built between 1930 and 1931, spanning the Narrows that separate Elizabeth City from Camden County. Pasquotank River Bridge was part of State Highway NC 34, which passed through Gates, Pasquotank, Camden, and Currituck Counties before entering Virginia. The new bridge was one of several projects approved by the State Highway Commission in March 1930. This project was also one of the costliest contracts awarded at the time; the Atlantic Bridge Company, of Greensboro, North Carolina, won the job with a bid of $348,057.50. Construction began that July, and crews completed work on the new bridge the following summer. The image below shows the wooden through traffic artery, in front of the completed bridge, before its demolition.

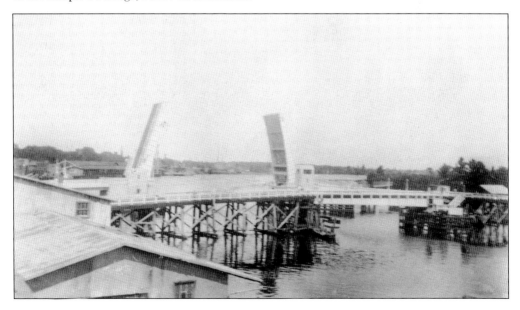

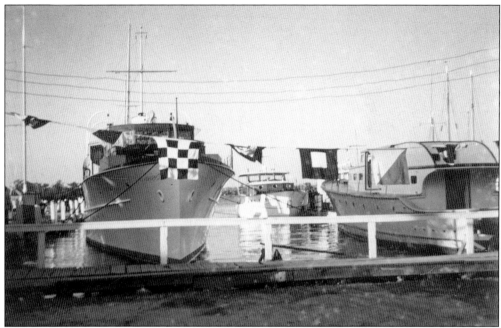

This photographic view of the yacht basin was taken around 1940. Pleasure yachts like the ones depicted here plied North Carolina's intercoastal waterways, stopping over in Elizabeth City for brief respites. Even today, boaters journeying through the Dismal Swamp Canal often dock at Mariners' Wharf to rest and enjoy the Harbor of Hospitality.

Sailors and yachtsmen would frequently visit the shipyard and marina for equipment, supplies, and repairs during their voyages. Elizabeth City was a one-stop shop for those traveling by water, treating both first-time guests and returning seafarers with old-fashioned Southern charm. The building seen in this image was one of several that dotted the shipyard, though, like many, it was later demolished.

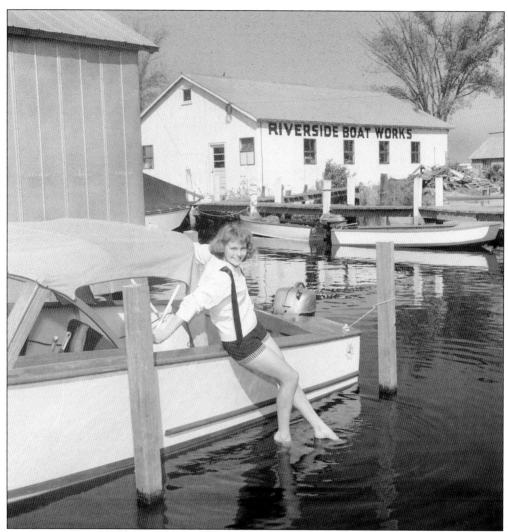

Riverside Boat Works sat between the Elizabeth City Shipyard and the mouth of Charles Creek, on Riverside Avenue. Dorr F. Willey, grandson of Edward S. Willey, owned and operated the boat works at the time this picture was taken in 1956. Dorr Willey's father, Howard A. Willey, owned and operated a machine shop on the general site where Riverside Boat Works was later located; present-day Coast Guard Park now occupies this site. The boat works would remain in the Willey family until grandson Dorr sold the business to Mary Hadley Griffin in 1972. Griffin's passion for boatbuilding and repair furthered the rich shipwright tradition that was a staple industry for generations in Elizabeth City. The girl posing in this photograph by Jack Williams is Barbara J. Hansen, Elizabeth City High School, class of 1959.

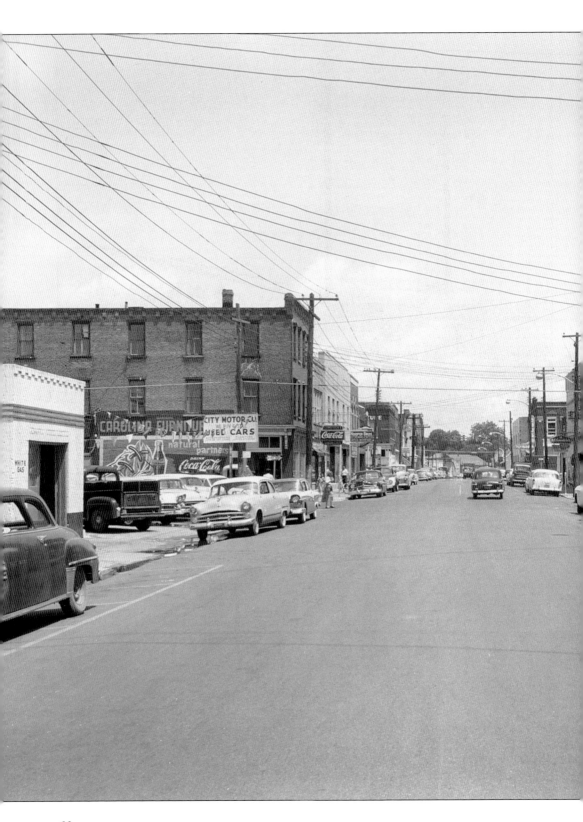

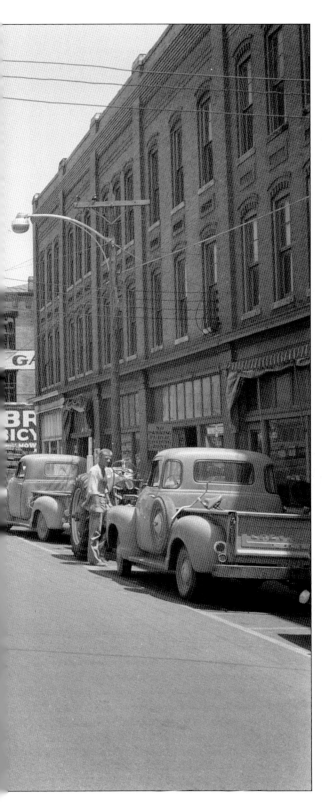

By mid-century, a multitude of local shops, stores, and companies lining Water Street helped cultivate a vibrant downtown business district in Elizabeth City. This view, taken on July 7, 1958, shows the several businesses occupying Water Street, from the 200 Block of South Water Street looking north to around Burgess Street. Some of the storefronts visible from this vantage point include Buxton White Seed Company (202–204 South Water Street), Brock's Bicycle Shop (116 South Water Street), Comstock Confectionery (115 South Water Street), Hooper Brothers Office Supplies (109 South Water Street), Garrett Hardware Company (112–114 South Water Street), and Economy Auto Supply (110 South Water Street). Farther north on Water Street was where some of the city's older industries resided like the Globe Fish Company and Crystal Ice and Coal Company.

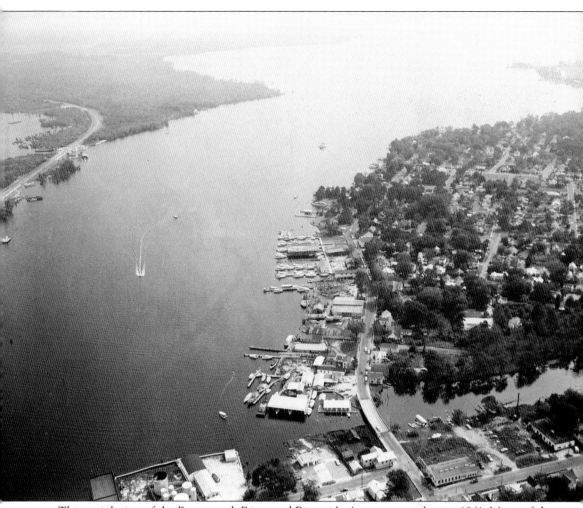

This aerial view of the Pasquotank River and Riverside Avenue was taken in 1961. Many of the facilities and homes situated along the riverfront in this photograph make up today what is known as the Riverside Historic District. The district's main thoroughfare, Riverside Avenue, includes the Charles Creek Bridge, which can be seen near the bottom of the image. The plot of land below the bridge and to its right was once the site of the Kramer Brothers and Company sawmill. The complex of buildings located above the bridge and to its left, at the mouth of Charles Creek, is the Riverside Boat Works. Farther east on Riverside Avenue is the Elizabeth City Iron Works and Supply Company's shipyard and marina. The stretch of road along the upper left side of the photograph is part of the Camden Causeway that runs across Machelhe Island in Camden County.

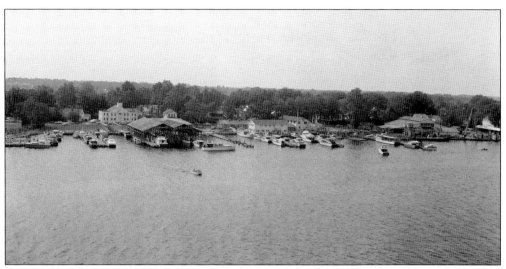

Another 1961 aerial view of Riverside Avenue features the whole of the Elizabeth City Shipyard and marina situated along the Pasquotank River. Calvary Baptist Church and Hunter Street are visible towards the left side of the image. Towards the right side is the large shipyard machine shop. In the center, between these two structures, is the marina or yacht basin, which includes the covered docks in front of the church.

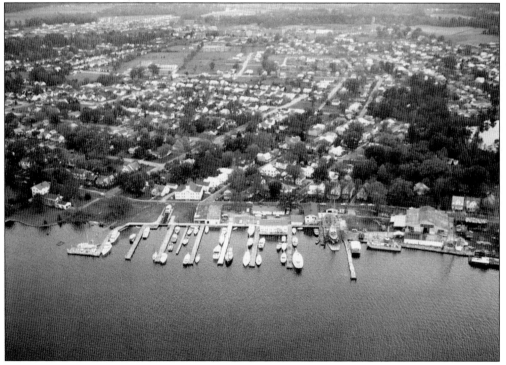

This aerial view of Riverside Avenue and the surrounding neighborhoods south of the riverfront was taken in 1963. In comparing this aerial view with the one above, the shipyard and marina have remained virtually unchanged. One noticeable difference is that the large, covered docks in front of Calvary Baptist Church have been removed. In the far background, at the top center of this image, is the campus of Elizabeth City State College in 1963.

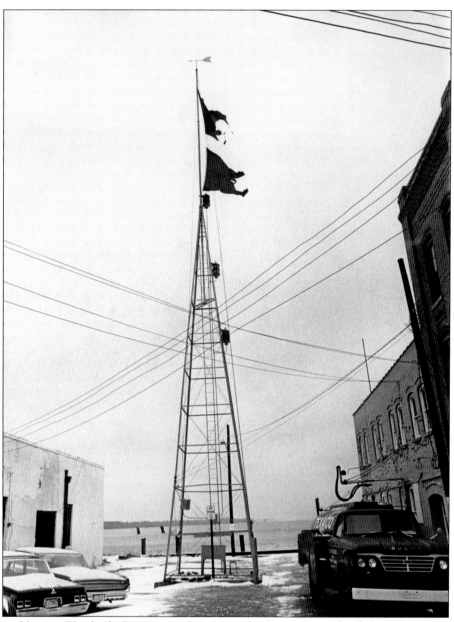

Pictured here is Elizabeth City's coastal warning display tower at the foot of Fearing Street overlooking the Pasquotank River around 1967. Implemented by the US Weather Bureau under President McKinley, coastal warning display towers served as an advanced hurricane and storm warning system for those at sea. Using a combination of signal flags of different colors and shapes, sailors would be alerted to whatever severe weather conditions were looming in the region; at night, a series of white and red signal lights communicated these storm warnings. Erected in March 1904, the coastal warning display tower in Elizabeth City stood at the Fearing Street riverfront for much of the 20th century, informing boaters of fair and adverse weather conditions for nearly 80 years. The flags hoisted on the tower in this photograph, while tattered, likely suggest a gale warning in effect. Several towns along the North Carolina coast kept such towers until the National Weather Service's Coastal Warning Network was deactivated in 1989.

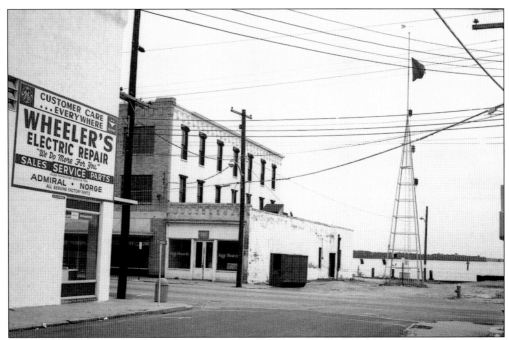

These two photographs show differing views of the intersection at East Fearing and South Water Streets in October 1973. The photograph above includes an additional view of the coastal warning display tower at the foot of East Fearing Street. According to local legend, this is the site believed to be where Betsy Tooley, an early resident of the town and for whom Elizabeth City was supposedly named, erected her noted tavern. Riggs Music Co. (116 South Water Street) occupied the building at the corner, which no longer stands; Mariners' Wharf Park is located on the site today. The photograph below features a view toward the southern end of Water Street. The row of storefronts on the right, which Hooper Brothers once occupied, are currently home to the Singer Sewing and Vacuum Center, on the corner, and Cypress Creek Grill.

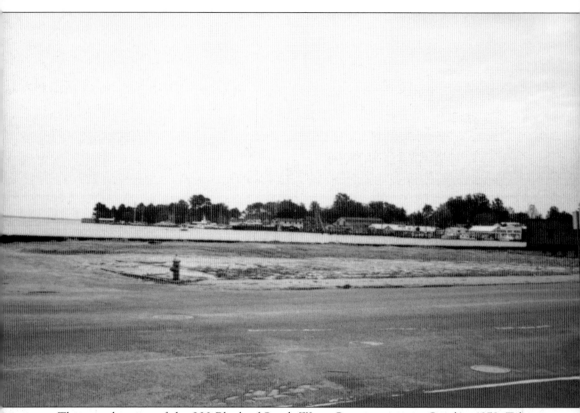

This was the view of the 200 Block of South Water Street as seen in October 1973. Taken at Fearing Street, the fire hydrant on the corner in this photograph is the same one pictured in the image of the coastal warning display tower on the preceding page. In years past, a three-story brick building, constructed by C.H. Robinson in 1911, occupied this empty lot. W.H. Weatherly operated his grocery and candy business there prior to moving into his own three-story factory on North Water Street around 1923. Miles Clark's oil distribution headquarters sat on the waterfront, directly behind the Robinson building, on Fearing Street. Parking for Mariners' Wharf Park and the city's public boat slips occupy this site today. Across the harbor lies an unobstructed view of the shipyard and yacht basin; Riverside Boat Works is visible at right.

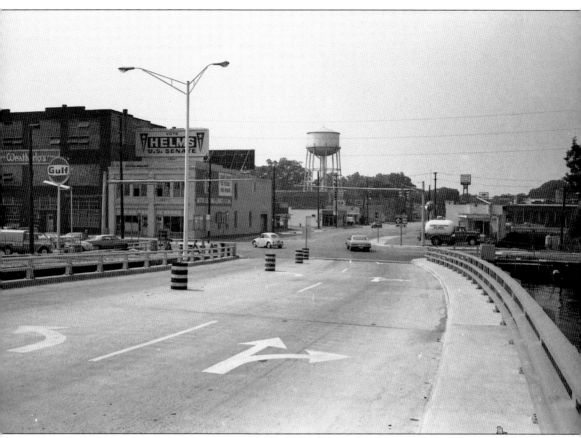

Taken from the Pasquotank River Bridge looking west, this image of the intersection of North Water and Elizabeth Streets dates to around 1973. The three-story W.H. Weatherly and Company building is visible at left. W.H. Weatherly moved his business into this building following its completion, and the company remained at this location, continuing its candy-making operations, until 1977. The building was recently renovated, finding new life as an apartment complex, and opened to the public as Weatherly Lofts in 2020. The white, two-story building to its right was once home to the Elizabeth City Coca-Cola Bottling Works. Erected in 1918, this structure housed the bottling works until the late 1920s. The Motor Bearings and Parts Company later occupied this site for many years before moving in the late 1970s. The building was then demolished, and the lot is currently used by the adjacent Weatherly Lofts.

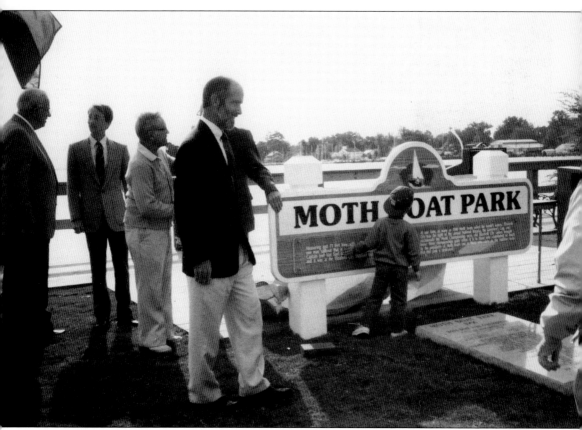

Today, a handful of parks dot the Elizabeth City waterfront, offering public recreation and leisure where once industry prevailed. Nestled at the foot of East Main Street lies perhaps the smallest of these waterfront parks, Moth Boat Park. Dedicated on September 21, 1991, the day of that year's Moth Boat Regatta, this park honors the little local watercraft that had an enormous impact on sailing communities the world over. The image above depicts some of the guests of honor following the dedication ceremonies. Elizabeth City mayor Sid Oman stands at far left speaking with Steve Gabriel of the North Carolina Division of Coastal Management. Noted Elizabeth City pilot Joe Flickinger is seen standing between Gabriel and Pasquotank County commissioner Jim Thornton. As a memorial to this legendary sailing vessel, Moth Boat Park continues to be visited by tourists and locals alike.

Hurricanes are regular occurrences out on the North Carolina coast, and Elizabeth City is no stranger to the flooding and damage wrought by these powerful forces of nature. The image above shows the intersection of Shepard and South Water Streets, looking east, following Hurricane Fran in early September 1996. While this hurricane tore through and severely battered the central part of the state, Elizabeth City recorded a storm surge of between four and six feet. The floodwaters can be seen by the entrance to Antioch Presbyterian Church at left. Two months prior to Hurricane Fran, Hurricane Bertha hit the North Carolina coast during the second week of July 1996. The image below shows Pelican Marina on Machelhe Island inundated by the Pasquotank River's rising tides during the storm. Part of the Elizabeth City Shipyard can be seen in the background.

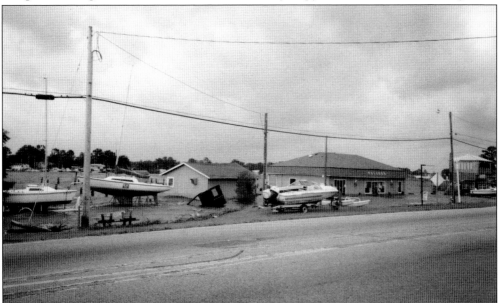

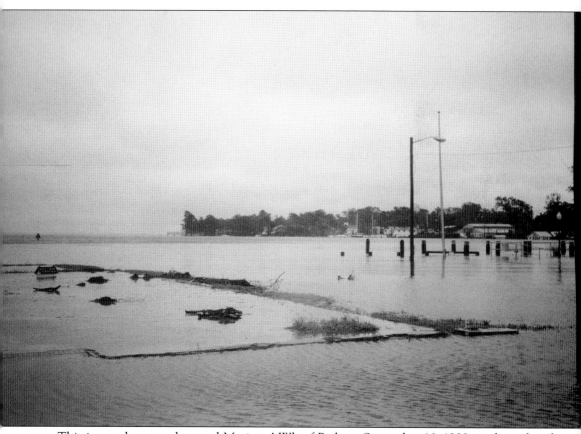

This image shows a submerged Mariners' Wharf Park on September 16, 1999, in the wake of Hurricane Floyd. Seen towards the right side of the image are the tops of the pilings for the boat slips at the wharf. Hurricane Floyd was estimated to be 580 miles across and carried with it tropical storm force winds. The hurricane's eye passed over Elizabeth City, causing a five- to six-foot storm tide, which was enough to swell the banks of the Pasquotank River. Combined with driving winds, eight blocks of the downtown business district flooded. The Elizabeth City Coast Guard Base recorded a sustained wind speed of 39 miles per hour with gusts of more than 60 miles per hour. The storm deposited over 2.5 inches of rain on Elizabeth City. Hurricane Floyd was one of the costliest and deadliest storms the state has ever endured, with billions of dollars in damages and 51 lives lost.

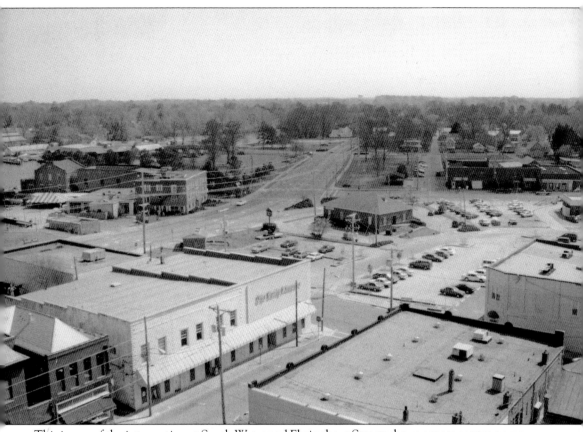

This image of the intersection at South Water and Ehringhaus Streets shows a more contemporary view of the Elizabeth City waterfront near the turn of the 21st century. Situated on the south side of Ehringhaus Street, on the right side of the image, is the former Elizabeth City Coca-Cola Bottling Works and, in the adjacent building, Davenport Motors. These two buildings once stood on the site that the Museum of the Albemarle now occupies. Prior to the museum's construction, Walston Street extended north to Ehringhaus Street, and the bottling works sat at the corner of these two streets. In the foreground, the *Daily Advance* newspaper offices can be seen on South Poindexter Street. Established by former high school teacher Herbert Peele, Elizabeth City readers got their first issue of his then weekly publication in May 1911. Peele would remain involved with the *Daily Advance* until he sold the paper in 1949.

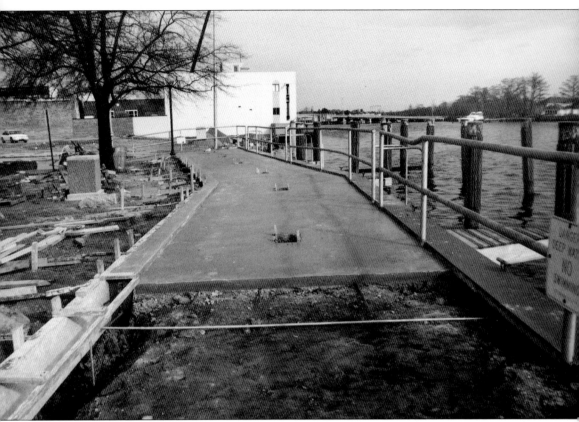

Mariners' Wharf undergoes renovations in this photograph of the Elizabeth City waterfront taken on Christmas Eve 1999. Community projects like Mariners' Wharf have sought to beautify the downtown area, encouraging residents as well as travelers to visit and enjoy Elizabeth City. Townsfolk have welcomed boaters to the Harbor of Hospitality at this wharf since 1982, when 10 boat slips and an adjacent park were constructed near the intersection of South Water and East Fearing Streets. It was here in 1983 that the famed "Rose Buddies" were born when Fred Fearing and Joe Kramer first greeted incoming sailors with refreshments and blossoms from Kramer's own garden. Today, those arriving by boat receive 48-hour complimentary dockage and are within walking distance of several local attractions, shops, and restaurants. Mariners' Wharf also doubles as a prominent venue for the downtown waterfront market as well as other events like the Mariners' Wharf Film Festival and Music on the Green. (Courtesy of Visit Elizabeth City.)

Two

COMMERCE AND INDUSTRY

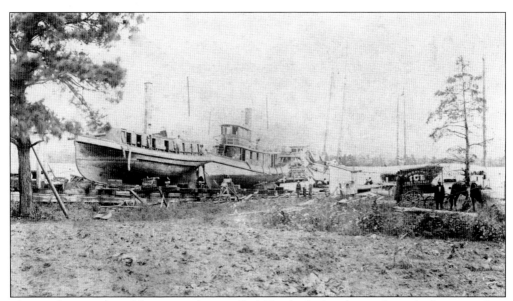

Plenty of marine-based businesses have called Elizabeth City home through the years. One short-lived boatbuilding and repair enterprise at the start of the 20th century, the Hayman and Fearing Boat Works, was the partnership of Thomas B. Hayman and John B. Fearing. However, their joint venture remained active for only a few years, and they dissolved the firm in May 1904.

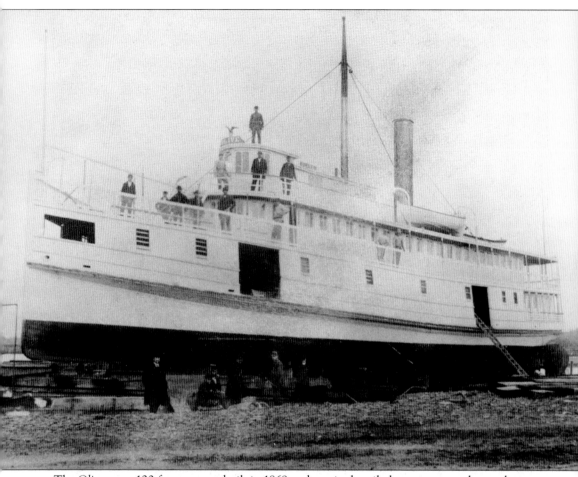

The *Olive* was a 120-foot steamer built in 1869 and routinely sailed passengers and cargo between Franklin, Virginia, and Edenton for the Albemarle Steam Navigation Company. A severe storm sank the river steamer in the Chowan River on February 16, 1903. Seventeen lives were lost in the wake of the tragedy. Following her ill-fated wreck, the *Olive* was raised, rebuilt, and continued to serve with the Albemarle Steam Navigation Company fleet as the *Hertford* for many years afterwards.

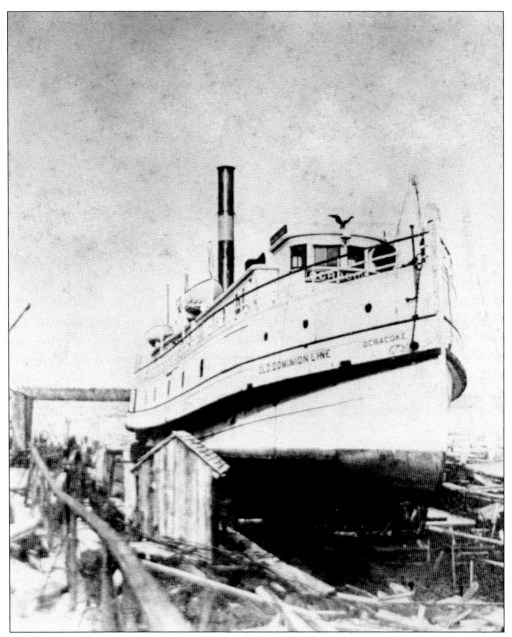

The steamer *Ocracoke*, built in 1898, was one of many passenger steamers operated by the Old Dominion Steamship Company. Elizabeth City was one of her ports of call, ferrying passengers and cargo around the inland waterways of Virginia and North Carolina. The steamer and her crew rescued several visitors and residents from Ocracoke Island following a severe storm that hit there in August 1899. Many of the island's businesses and homes, including that of the ship's commander, Capt. David Hill, were destroyed in the squall.

Headquartered in Elizabeth City, the Globe Fish Company was one of North Carolina's biggest commercial seafood processing companies during the first half of the 20th century. Dare County native Ezekiel R. Daniels, along with the help of sons Arthur S. and John P., established the company in 1911. The Daniels operated facilities in Wanchese as well as a small fleet of vessels with which to haul their catches back to Elizabeth City. The Globe Fish Company acquired the *Hattie Creef* (below) to serve their Wanchese Line, plying a daily route with one of her sister ships, *Pompano*, to and from Roanoke Island. The boats ferried passengers and mail, in addition to iced fish, on these routes and were dependable as well as vital to those living on the island. (Above, courtesy of the *Independent*, April 30, 1920, newspapers.com.)

Formed in partnership by merchants John B. Brockett, Jerome B. Flora, and Daniel B. Bradford in 1890, the Elizabeth City Ice Company began manufacturing operations at its Water Street plant the following year. In 1897, coal was added to the company's business interests, and by the turn of the century, the Crystal Ice and Coal Company advertised a daily ice capacity of no less than 25 tons. The Crystal Ice and Coal Company remained in business on Water Street until the mid-1960s. (Courtesy of the *Tar Heel*, April 25, 1902, newspapers.com.)

Fred Davis's Coal Yard once occupied a prime waterfront locale along the Elizabeth City Harbor during the late 19th and early 20th centuries. In 1891, Davis bought the business from his former employer, Whitehurst, Rawlings, and Company. He would grow the enterprise over the next three decades to include a 2,000-ton storage yard, wagon house, offices, and coal trestle. A coal wholesaler and retailer for nearly 40 years, Davis remained Elizabeth City's "coal man" up until his death in 1917.

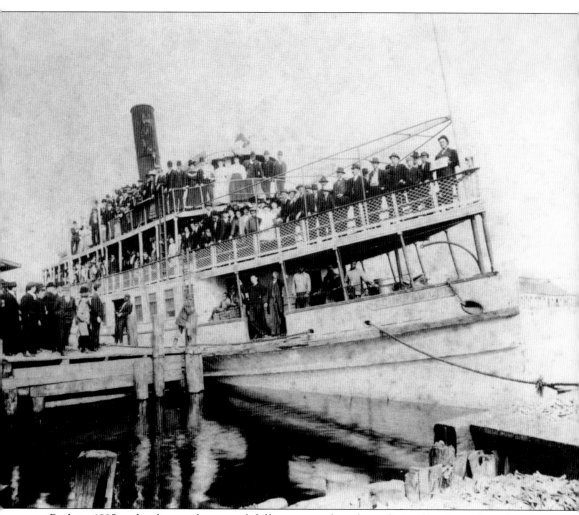

Built in 1895 and sailing under several different steamboat lines during her time of service, the *General Lee* began plying the waters of the upper Albemarle Sound around 1909. In 1907, the Ocean Navigation Company of Norfolk purchased the *Rock Creek* from the Rock Creek Steamboat Company of Baltimore before renaming the steamer. Capt. Benjamin F. McHorney commanded the boat, ferrying passengers between Newport News and the fairgrounds in Norfolk during the Jamestown Exposition. Two years later, the Banks Steamboat Line acquired the services of Captain McHorney and the *General Lee* to carry tourists between Elizabeth City and Currituck County. The Banks line folded soon after, and the steamer was eventually sold to J.H. Welch. Welch took her to Fairhope, Alabama, where on the morning of December 13, 1910, the *General Lee* caught fire and burned at her wharf.

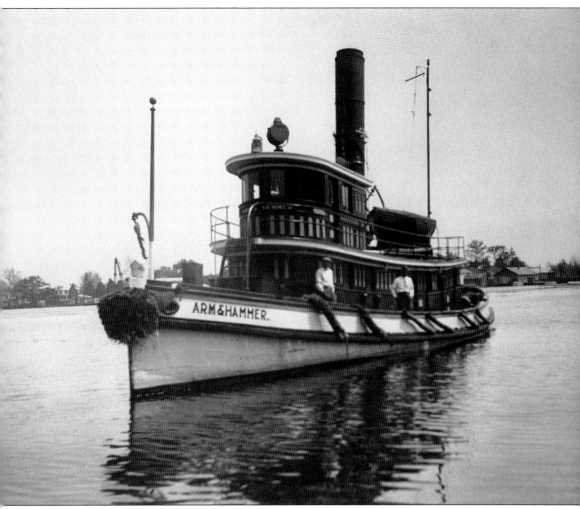

Built in 1883, the tugboat *Arm & Hammer* first launched in New York under the name *George H. Reeves*. One of the tug's original owners, James A. Church, was the son of Austin Church, who marketed the popular Arm & Hammer brand baking soda. J.A. Church took the ship to North Carolina, where she served the Cashie & Roanoke Railroad and Lumber Company, hauling timbers from Bertie County. J.W. Branning bought out the Cashie & Roanoke Railroad in 1890, acquiring the tug and renaming her three years later. Sturdy and well-maintained, the *Arm & Hammer* continued serving logging operations and crews in and around the waters of Albemarle Sound well into the 20th century.

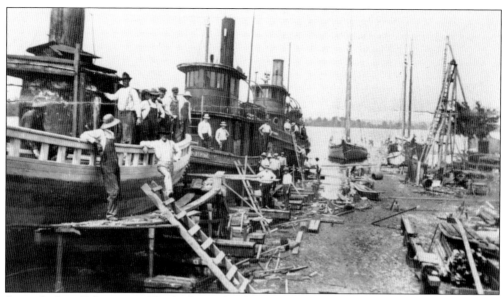

Since the late 19th century, Elizabeth City has been home to several shipyard and marine railway operations. In the photograph above, men at the Willey Shipyard break from their work building tugs and other vessels on the Pasquotank River. Edward S. Willey opened his shipyard and marine railway in 1890, growing to become a successful shipbuilding and repair business by the time his son Howard A. Willey assumed control. Most of these operations included their own foundries and machine shops so that fabrication and repair work could be conveniently completed in-house. The Willey Machine Works functioned as a division or department within the Willey Railways and Shipyard. The receipt below, dated September 1926, is for work completed on the steamer *Tamarack* of Miles Clark's oil distribution fleet.

H. A. WILLEY, PROPRIETOR AND MANAGER

WILLEY MACHINE WORKS
All Kinds of Machine Work Done Neat
MARINE RAILWAYS AND SHIPYARD, BUILDING AND REPAIRING
SUPPLIES CARRIED IN STOCK

RIVERSIDE AVENUE PILEDRIVING - LAND AND WATER

Elizabeth City, N. C., Sept 1st 1926 192____

Str. Tamarack & Owner.

1925

June 17 To 1 Hour Mach on gong hammers 1 30

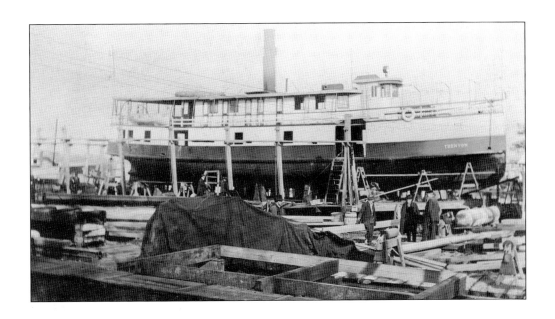

The steamer *Trenton* began plying the waters between Elizabeth City, Manteo, and Nags Head in July 1914. She initially served under the Johnson Line, headed by the seasoned Capt. Martin Johnson, to compete with the Eastern Carolina Transportation Company. The latter firm, Johnson's former employer, was soon bought out by Johnson. The ship would take up the famed *Hattie Creef*'s old route, making scheduled runs of passengers, cargo, and mail to and from Roanoke Island. The *Trenton* continued service between Elizabeth City and the Outer Banks until the mid-1930s. By that time, construction projects like the Wright Memorial Bridge made driving to the coast a more preferred means of travel.

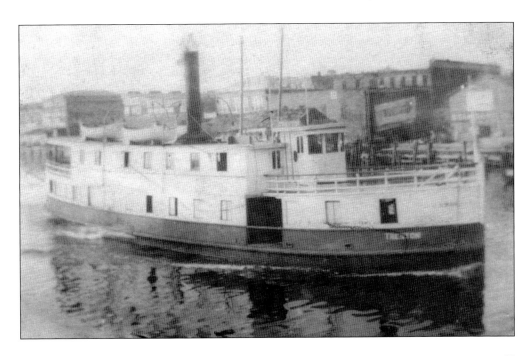

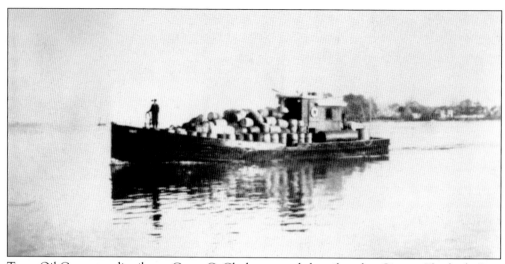

Texas Oil Company distributor Carey C. Clark operated the oil tanker *Goat* in Elizabeth City. On February 19, 1918, the tanker, laden with some 13,000 gallons of gasoline and sailing for Hertford, exploded at the mouth of the Perquimans River. The bodies of Captain Clark and David T. Williams were later recovered, and both men were laid to rest at Old Hollywood Cemetery. In the wake of Captain Clark's death, his son Miles L. Clark continued his family's business and became a prominent Elizabeth City local. (Below, courtesy of the *Charlotte News*, February 20, 1918, newspapers.com.)

GASOLINE TANKER EXPLODED.

Norfolk, Va., Feb. 20.—A gasoline-propelled oil tanker, the Goat, operated out of Elizabeth City, N. C., to North Carolina sound points by the Texas Oil Company, exploded early yesterday afternoon. Capt. C. P. Clark and David Williams, in charge of the boat are missing and it is believed lost their lives. Other boats in the vicinity, seeing the explosion went to the scene but found no traces of the two men. A searching party has left Elizabeth City to locate the missing men or recover their bodies.

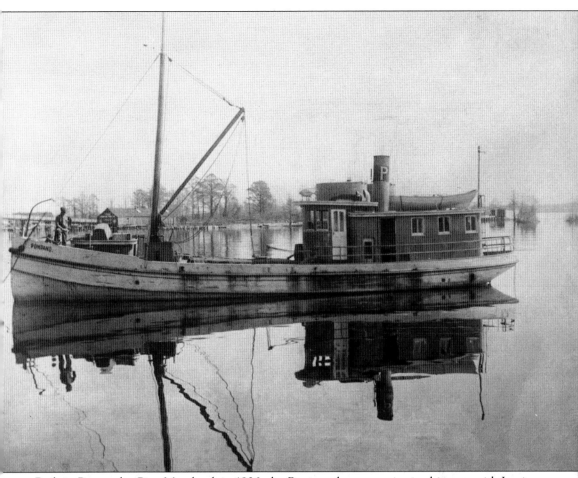

Built in Pocomoke City, Maryland, in 1906, the *Pompano* began service in this state with Louis Feuerstein's shipping line in Elizabeth City. The motorized freighter sailed passengers, seafood, and mail from the Harbor of Hospitality to ports along the Outer Banks, including Manteo, Hatteras, and Ocracoke. She then plied this route with her sister ship, *Hattie Creef,* for the Globe Fish Company's Wanchese Line. The *Pompano* was later chartered by the US Navy during World War I, serving as a supply boat with the Fifth Naval District headquartered in Norfolk, Virginia. By war's end, the 15-ton workboat had returned to her usual commercial freighting duties for the Globe Fish Company. A regular maritime workhorse, the *Pompano* was dubbed "one of North Carolina's busiest boats" in the June 1920 issue of *Motor Boat* magazine.

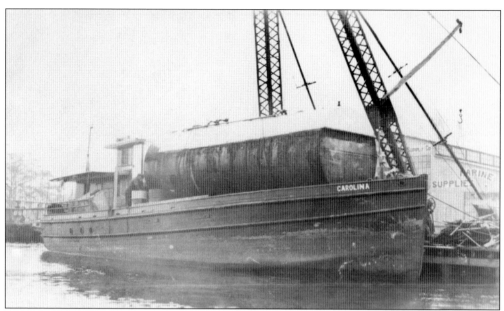

Carolina was part of the small fleet of ships that delivered oil and gas products for the Texas Oil Company, later Texaco, to people and businesses around coastal North Carolina. The image above shows the vessel docked at the Elizabeth City Shipyard with its large oil tank suspended from the yard's 50-ton shear leg derrick. The oil tanker ran aground near Masonboro Inlet, south of Wrightsville Beach, on November 10, 1931, and had to be pulled off the shoals with the aid of the US Coast Guard. Another noteworthy event regarding the *Carolina* involved the rescue of four men on the morning of July 14, 1940. The tanker saved the crew after their boat developed engine trouble and began sinking in the Albemarle Sound and returned them safely to Elizabeth City.

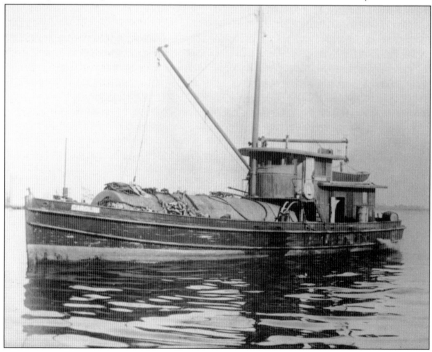

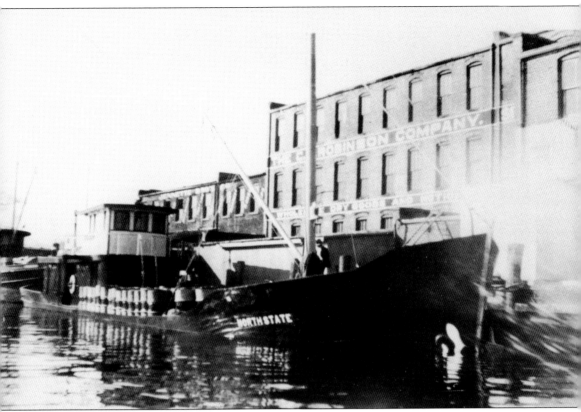

The tanker *North State* also served the Texas Oil Company in Elizabeth City, supplying oil, gasoline, and other petroleum products to towns and communities all throughout northeastern North Carolina. This image shows the *North State* docked near the foot of Fearing Street, where Miles Clark managed his oil distribution company. The buildings behind the tanker housed C.H. Robinson and Company, a dry goods wholesaler, and the Jennette Brothers Company, a wholesale produce firm still in business today. The tanker *Carolina* can be seen moored in the background.

IRON WORKS ACQUIRES 700 FT. WATER FRONT

Sanders Brothers Plan to Build Steel Ship Building Plant on Riverside Avenue

The Elizabeth City Iron Works & Supply Co. has purchased the Riverside Ave. water front property of the Elizabeth City Fuel & Supply Co. and will build thereon iron shipbuilding and repair plant equipped to handle any job that can be brought to Elizabeth City. The Sanders brothers, owners of the Elizabeth City Iron Works & Supply Co., will spend $100,000 or more on the new plant.

Whether the shipbuilding plant will be operated in connection with the Iron Works already established, or whether it will operate as an independent corporation has not yet been determined.

The site puchased has a frontage of 700 feet on Riverside Ave. between The Elizabeth City Ship Yard Co. and the Snell property. The Messrs. Sanders expect to erect the first building on the property at an early date, but indicate that they will not rush with the perfection of their ultimate plans.

In 1919, the Elizabeth City Iron Works and Supply Company acquired additional riverfront acreage on which to build a state-of-the-art shipbuilding and repair plant. Brothers Brad, Andrew, and Henry Sanders purchased property adjacent the Willey Marine Railways near present-day Riverside Avenue and Hunter Street. The shipyard, a division of the Elizabeth City Iron Works and Supply Company, would prosper as a viable maritime industry in the city over the next 50 years. (Courtesy of the *Independent*, October 24, 1919, newspapers.com.)

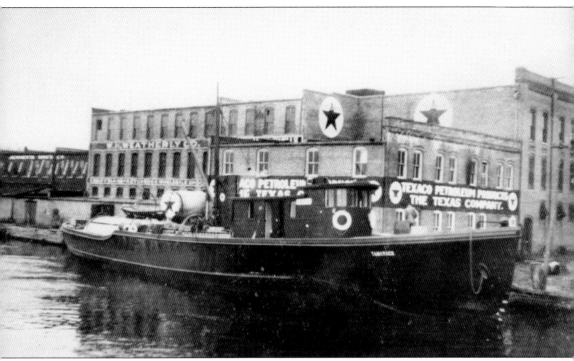

Originally built in 1913 as a pleasure vessel, the *Tamarack* was purchased in 1920 by wealthy Detroit surgeon Dr. Henry N. Torrey. Returning from a duck hunting trip at the Pea Island Club, Dr. Torrey and his boating party were forced to abandon ship on the afternoon of December 4, 1921, during a turbulent storm when the yacht caught fire in Pamlico Sound. Crews from four different US Coast Guard lifesaving stations, including the noted African American Pea Island crew, assisted in the rescue effort, and no lives were lost in the inferno. Dr. Torrey's *Tamarack* was later dredged and towed to Elizabeth City in April 1922 where she was converted into an oil tanker to serve in Miles Clark's Texas Oil Company fleet.

NORTH RIVER LINE, Inc.

FORMERLY

PASQUOTANK & NORTH RIVER STEAMBOAT CO.

General Office—Jarvisburg, N.C.

W. H. GALLOP, Sr., President, Jarvisburg, N.O.
Dr. J. M. NEWBERN, Vice-President, "
C. H. BROOK, Treasurer and Gen. Supt., Elizabeth City, N.O.
J. B. BAKER, Auditor, "
W. G. GAITHER, Secretary, "

Steamer "Annie L. Vansciver."

..........	a 200 Night	lve...... Cojnjock, N.Carr.	9 00 P M
..........	3 00 A M	» ...Barnett's Creek, N.C ..lve.	7 30 »
..........	4 00 »	» Jarvisburg, N.Clve.	6 30 »
..........	4 30 »	» .Newbern's Landing, N.C. »	5 30 »
..........	6 00 »	»Old Trap, N.C...... »	4 15 »
..........	6 30 »	» ... Cowells Wharf, N.C ... »	3 30 »
..........	b 7 30 A M	arr..Elizabeth City, N.C..lve.	b 2 30 P M

a Monday Wednesday and Friday; *b* Tuesday, Thursday and Saturday *Eastern time.* *January, 1927.*

Connection.—At Elizabeth City, N.C.—With Norfolk South. R.R.

Chartered in July 1911, the Pasquotank and North River Steamboat Company was an offshoot of the former Banks line that operated the *General Lee*. First headquartered at the Norfolk & Southern Railroad's waterfront wharf in Elizabeth City, the steamer line ferried freight, produce, and passengers to and from points around lower Camden and Currituck Counties. In 1914, the company relocated to Jarvisburg in Currituck County, changing its name to the North River Line Inc. in the process. The steamer *Annie L. Vansciver* was perhaps the North River Line's most well-known vessel. During the summer beach season, Sunday excursions to Nags Head were routinely advertised and popular with tourists and locals alike. The North River Line would continue its passenger and freight services up until the late 1930s.

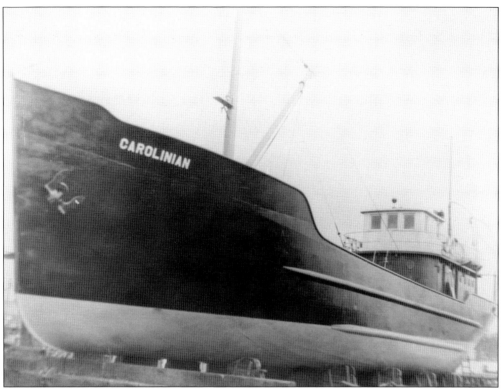

Seen in the above photograph is the tanker *Carolinian* in dry dock. Built by the Charleston Dry Dock and Machine Company, *Carolinian* was the first steel-welded commercial ship of its kind. Launched on February 14, 1930, she was completed the following month to great fanfare. Texas Oil Company distributor Miles L. Clark (below) purchased her to serve in his commercial oil fleet based in Elizabeth City. The tanker measured in at 120 feet in length and 23 feet wide and sported a 2,500-barrel or 125,000-gallon capacity hold for transporting oil. She was powered by a 6-cylinder, 180-horsepower Fairbanks Morse diesel engine.

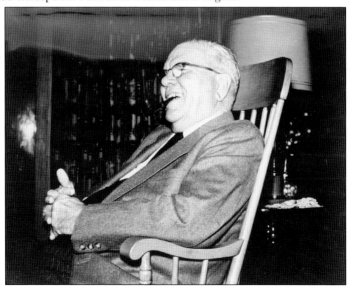

Richard F. Smith designed the *Carolinian* using a system of dovetail-notched, interlocking plates, eliminating the need for rivets or bolts while still creating a watertight seal. His method further proved economical by reducing materials as well as costs needed for production. It was estimated that 28,000 pounds of rivets were spared in the *Carolinian*'s construction, which was some 20 percent of the total weight of a vessel of comparable size. Smith's "rivetless ship," made possible by his patented lock-notch welded system, revolutionized the shipbuilding industry.

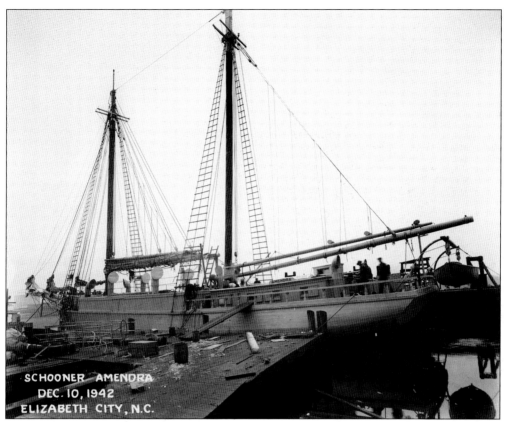

SCHOONER AMENDRA
DEC. 10, 1942
ELIZABETH CITY, N.C.

Here, Elizabeth City Shipyard workers repair and rebuild the schooner *Amendra* in late 1942. Originally named the *Anna Sophia*, this cargo ship launched from the Pushee Brothers Shipyard in Dennysville, Maine, on November 20, 1923. The 200-ton, double-masted schooner transported everything from black granite and coal to mahogany and bananas. Renamed the *Amendra* in 1941, she was under the ownership of the West India Fruit and Steamship Company around the time of her 1942 rebuild. The November 4 contract for the *Amendra* included a complete overhaul of the ship's rigging, masts, engines, and electric generators; new frames and planking; full hull repair; fresh paint; and a reconditioning of her propellers, shafts, and bearings. The total bill for the shipyard's services, labor, and materials came to $27,000.

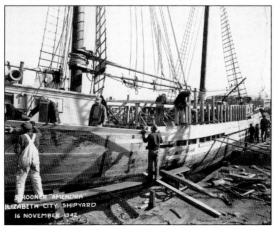

SCHOONER "AMENDRA"
ELIZABETH CITY SHIPYARD
16 NOVEMBER 1942

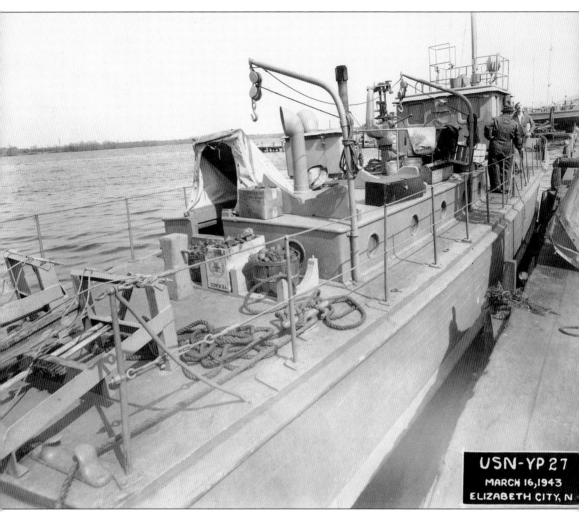

USN-YP 27
MARCH 16, 1943
ELIZABETH CITY, N.

The *YP-27* undergoes maintenance service at the Elizabeth City Shipyard in this image from March 16, 1943. Commissioned in 1925 as a US Coast Guard cutter, the *CG-302* was one of several patrol craft fitted to intercept rumrunners and other smugglers during Prohibition. In 1934, she was decommissioned and placed in service of the US Navy. The 75-foot cutter was assigned to the US Fifth Naval District based in Norfolk, Virginia, at the time of this photograph. She was struck from the Naval Register in May 1945.

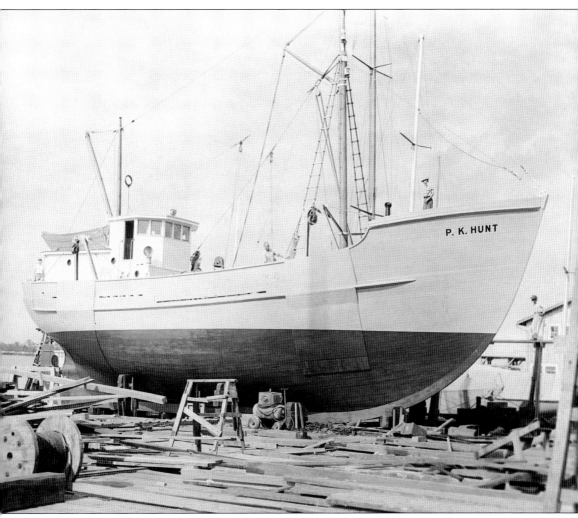

The Elizabeth City Shipyard launched its first modern commercial fishing trawler, *P.K. Hunt*, in March 1945. The 85-foot trawler was named for Powhatan Hunt, founder of the Hampton, Virginia–based seafood packaging firm P.K. Hunt and Son. Built at a cost of $75,000, the *P.K. Hunt* featured several new amenities and equipment for its time, including an oil-burning range, electric refrigerator, telephone, and navigation system. The *P.K. Hunt* met an unfortunate demise in the early morning of April 21, 1965, when the 190-ton ship caught fire and sank while fishing some 40 miles off the coast of Cape May, New Jersey.

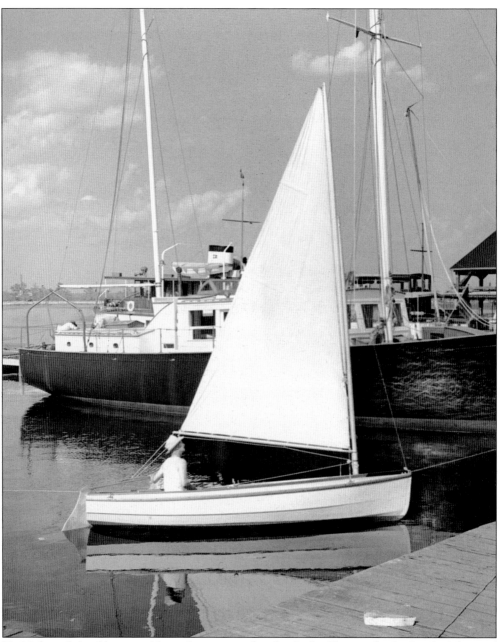

Highly knowledgeable, reputable, and experienced in the shipbuilding trade, the Sanders' shipyard could fabricate just about any type of made-to-order marine vessel. Dr. J.R. Rhodes of Portsmouth, Virginia, ordered the sailboat pictured here in 1946, exemplifying some of the smaller, custom-built leisure craft constructed in-house. Measuring 14 feet in length, the boat's total cost, including mast, sail, and centerboard, came to $675.

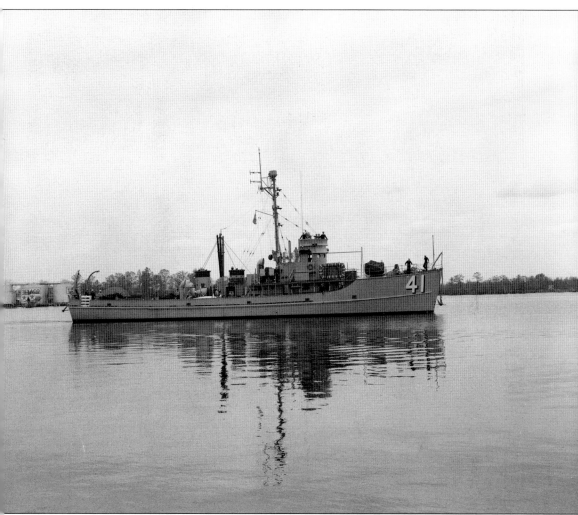

Elizabeth City was just one of several ports of call for countless commercial and military vessels sailing along the eastern seaboard. During the Second World War, the US Navy minesweeper USS *Barbet* (MSC[O] 41) served in the Pacific theater, conducting coastal minesweeping operations in and around the islands of Okinawa. Here, the USS *Barbet* and her crew prep for their trip south on April 11, 1955. This image shows the ship just prior to departing for Green Cove Springs, Florida, where she was decommissioned in June of that year.

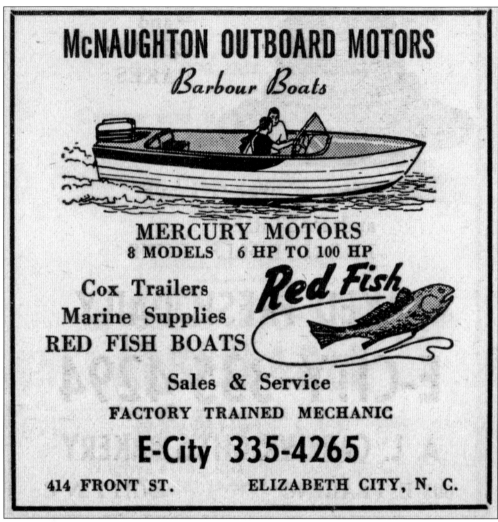
Longtime Elizabeth City resident Charles F. McNaughton Jr. opened his boat and marine supplies business around 1950, specializing in Mercury outboard motor sales and service. An avid powerboat enthusiast, he began organizing his own outboard motor races on the Pasquotank River in the spring and summer of that year. McNaughton occupied a storefront on South Water Street for much of the 1950s, finally moving to Front Street in the early 1960s. McNaughton Outboard Motors was one of several local businesses that catered to and earnestly promoted the interests of Elizabeth City's powerboat racing community.

Three

LEISURE AND
ENTERTAINMENT

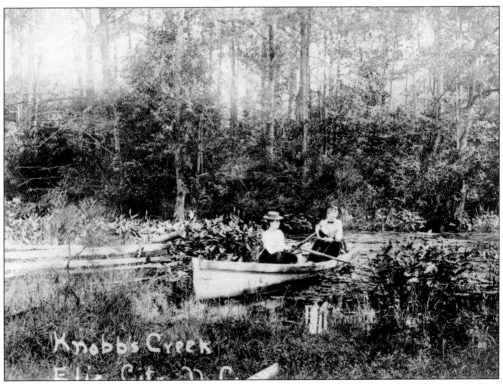

The water has always been a source of recreation and enjoyment in Elizabeth City. Boaters, anglers, spectators, and pleasure-seekers of all kinds have made their way to the Harbor of Hospitality for both festive play and peaceful respite. Here, two ladies enjoy a day of boating on Knobb's Creek, just north of downtown.

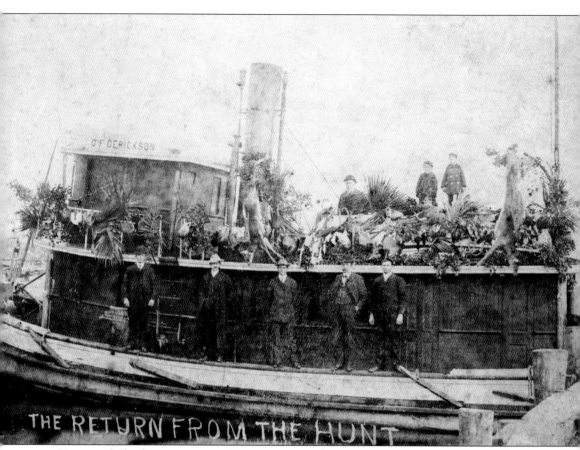

THE RETURN FROM THE HUNT

Hunting, for both sustenance and sport, remains a popular activity to this day on the sounds and rivers of northeastern North Carolina. Deer, rabbit, and especially wild fowl like duck, goose, and turkey attract hunters from all over to the shores of the Pasquotank River. Here, a hunting party aboard the tugboat *G.F. Derickson* poses with their catch in this turn-of-the-20th-century photograph. Elizabeth City native Samuel M. Rhodes, captain of the tug, stands atop the vessel. The tug, built in 1894 and named for the vice president of the Elizabeth City Lumber Company, served for many years with the local lumber mill operation Kramer Brothers and Company. In 1918, the US Navy commissioned the *G.F. Derickson*, renamed her the *Francis G. Conwell* (SP 3215), and placed the tug in service with the Fifth Naval District in Norfolk, Virginia, until 1921.

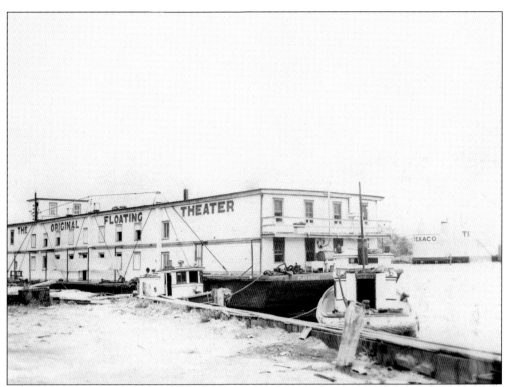

One of the most well-attended and best-talked about attractions to frequent Elizabeth City was the beloved James Adams Floating Theater. A driving inspiration behind Edna Ferber's classic novel *Show Boat*, the James Adams Floating Theater regularly toured the inland waterways of North Carolina as well as those of Virginia and Maryland for nearly three decades. Elizabeth City held a pride of place for this showboat as the Harbor of Hospitality was designated the theater's home port and off-season anchorage. The image above depicts the James Adams Floating Theater docked in Elizabeth City around 1938. The advertisement at right promoted the November show dates in Elizabeth City during the theater's 1921 season. (Right, courtesy of the *Daily Advance*, November 14, 1921, newspapers.com.)

COMING

James Adams

Floating Theater

November 14-19

With entirely new company and repertoire of plays.

Opening play, Monday, "The Man of the Hour."

Advance sale of tickets opens Monday morning at Theater Box Office, Main street wharf. Phone orders promptly attended to.

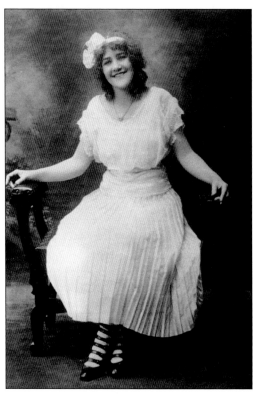

Stage actress Kathleen Wanda (left) and her troupe performed countless shows in theaters across the country during the early 20th century. Frequently touring with her husband and costar, noted actor and stage manager Walter Sanford, Wanda worked with such Broadway talent as Maud Adams, Ethel Barrymore, and William Crane. She and her acting company starred in a series of plays on board the floating theater following the 1914 season. This unique run of performances premiered between mid-January to mid-February 1915 exclusively in Elizabeth City. Below is a program from that special winter season featuring the Kathleen Wanda Company. One of the plays performed then, a melodrama entitled *A Woman's Warning*, was produced especially for Wanda by her husband.

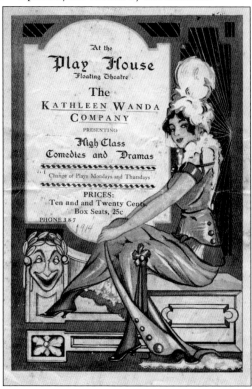

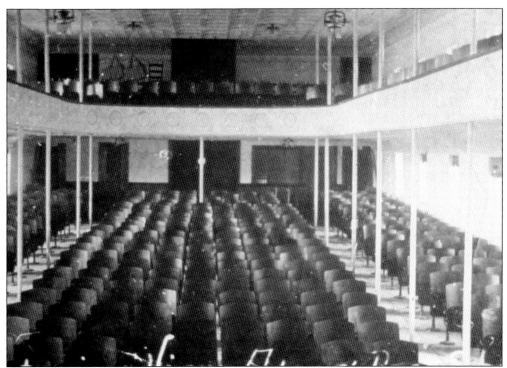

The above image of the theater interior was taken around 1927, likely following its renovation after sinking in the Chesapeake Bay in November of that year. During this time, the floating playhouse could accommodate an audience of 700. The theater was also home to a troupe of nearly 30 performers, musicians, and crew. James Adams, with the help of his family, managed this theatrical enterprise for 19 seasons, from its first year in 1914 until 1933 when Adams put the barge up for sale. Purchased by Nina Howard, a wealthy widow from St. Michaels, Maryland, the theater was renamed The Original Show Boat and placed under the management of her adopted son, Milford Seymoure. The image below shows some of the crew standing on the stern of the tug *Trouper* around 1938; at left is Captain Seymoure.

An instrumental and creative force during his time with the James Adams Floating Theater, Charlie Hunter took on several jobs aboard the showboat that greatly contributed to its legendary renown. He, along with his wife, Beulah, joined the cast for the theater's second season in 1915. As an actor in the troupe, Charlie played a host of characters, from lead roles and villains to comic types as well as other minor parts. He was a self-taught musician, playing coronet in the theater band, too. However, his work as the theater's director perhaps best exemplified Charlie Hunter's talent for the stage. In that position, he adapted many of the plays performed by the company, chose and prepared scripts, and managed the cast during rehearsals among other such duties. Charlie and Beulah quit the showboat at end of the 1936 season, having toured with the theater for 21 years. (Courtesy of the Mariners' Museum and Park.)

In the 28 seasons it plied the waters up and down the eastern seaboard, the James Adams Floating Theater suffered the misfortune of having wrecked on three memorable occasions. The first of these mishaps occurred on Thanksgiving Day in 1927. The playhouse, in tow to Elizabeth City for the winter, struck an object and sank near Thimble Shoals in the Chesapeake Bay. Two years later, in November 1929, the theater sank again in route to Elizabeth City, this time while navigating the Dismal Swamp Canal. The image above depicts the partially submerged stage at the time of the theater's 1929 misadventure just south of the locks at South Mills, North Carolina. The image below is that of the showboat following its sinking in the Roanoke River on its way to Williamston in 1938. (Above, courtesy of the Mariners' Museum and Park.)

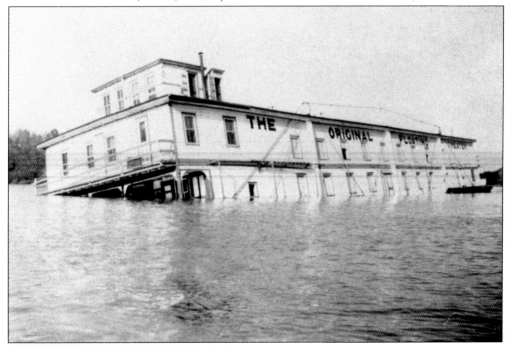

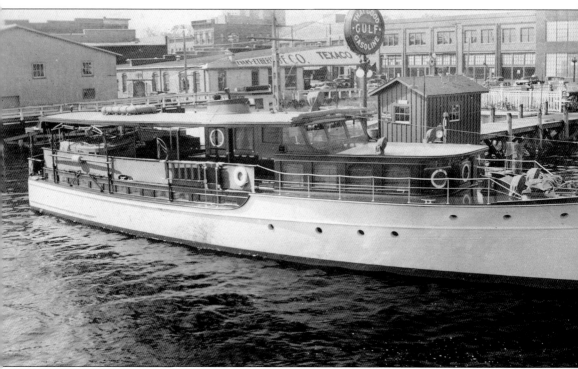

Built in 1932 by the New York Yacht, Launch, and Engine Company, *Antonia* was a state-of-the-art luxury yacht gifted to Elevator Constructors' union president Frank Feeney Sr. of Philadelphia. Measuring 77 feet in length, this custom pleasure craft sported teakwood-planked outer decks and a mahogany interior finish. Her fully furnished quarters, which included a dining saloon, captain's room, and bridge, were showcased in the January 1934 issue of *Motor Boating*. Powered by two six-cylinder Standard diesel engines, she could make 13 miles per hour in open water. The image above depicts the *Antonia* docked at the Gulf Oil filling station on North Water Street around 1934. Frank Feeney was an avid yachtsman and sailor, visiting Elizabeth City often on his cruises. His fondness for sailing and the sea eventually led him to become good friends with Capt. Joel Van Sant, and the latter even skippered the union president's yacht for a time. Feeney sold the *Antonia* in favor of his last and more modest vessel, *Tonya*, in 1937.

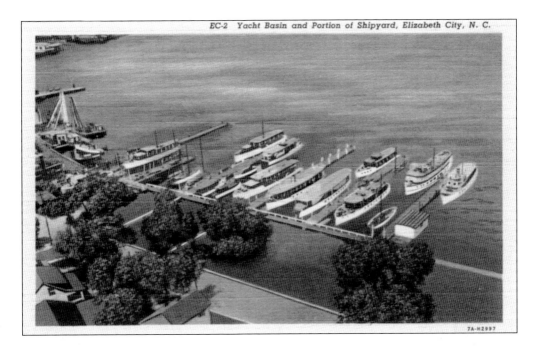

7A-H2997

These views depict the Elizabeth City Yacht Basin between the early to mid-1930s, around the time of the facility's height as one of the most modern yacht centers between New York and Florida. The accommodations and amenities offered by both the yacht basin and adjacent shipyard made Elizabeth City an attractive port of call for many boaters sailing the intercostal waterway. Improvements were made to the yacht basin in 1937 when the Elizabeth City Iron Works and Supply Company purchased additional riverfront property upon which to expand and attract water tourist traffic. The image below shows some of the more luxurious vessels docked at the yacht basin, including, second from left, the 106-foot *Viator*, owned by Rev. Maitland Alexander of Sewickley, Pennsylvania.

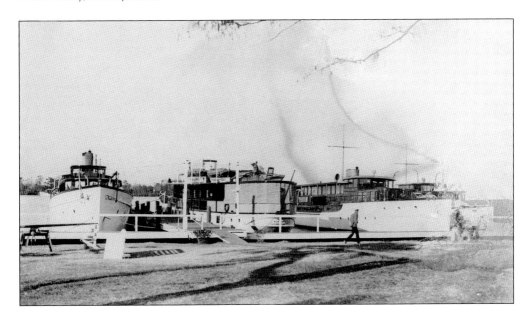

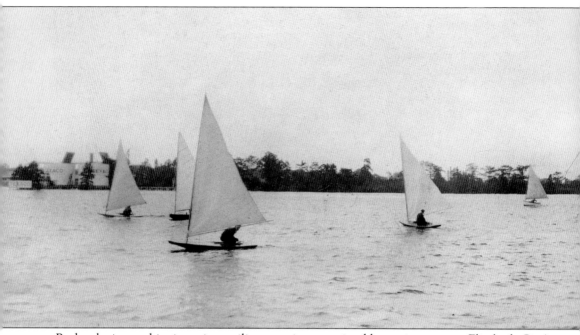

Both relaxing and invigorating, sailing remains an enjoyable pastime among Elizabeth City's residents and visitors alike. Here, sailors pilot their Moth boats on the Pasquotank River in this photograph from around 1935. The introduction of the Moth boat to Elizabeth City's waters in 1929 attracted a great deal of interest and attention from sailors at home and abroad. During the 1930s, popularity in the tiny vessel quickly grew, and boaters were soon sailing their Moths for both leisure as well as sport. By 1937, over 1,500 of the small yet agile craft could be found in waters around the world. Today, Moth boats can still be found sailing up and down the river around Elizabeth City, especially during the warmer months in the lead-up to the national regatta usually held in October.

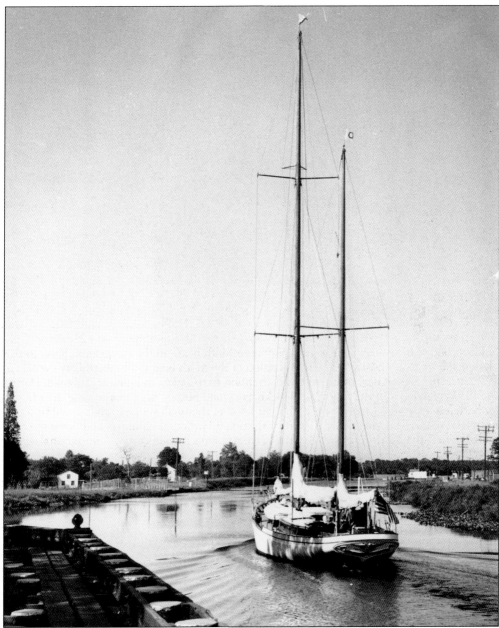

Many a sailor has journeyed far and wide, even risking life and limb, for the promise of adventure, exploration, and fortune in distant lands. A handful of young seafarers made such an excursion in 1952, when a crew of six sailed the ketch *Ailsing* from Galway Bay, Ireland, to America in May of that year. The group's transatlantic crossing took them to such places as Morocco, the Canary Islands, Puerto Rico, and Cuba before heading north. By the time the *Ailsing* and her crew moored in the Harbor of Hospitality, only Anthony Jacob and Anthony Blyth remained on board. The two Irishmen, who were interviewed by Elizabeth City photographer Jack Williams, continued up the East Coast to New York with the hope of finding work. Their story appeared in the August 18, 1952, issue of the Raleigh *News & Observer*. The image here shows the *Aisling* making way up the Pasquotank River.

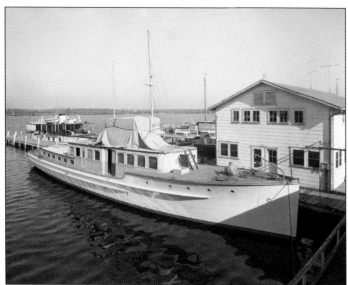

Gypsy was the pleasure yacht of Elizabeth City Shipyard president and general manager Ernest J. Sanders. Built in 1928 for Boston attorney Robert F. Herrick, the 101-foot wooden yacht was later purchased by the US Navy for $1. She was renamed YP-70 and served with the Fifth Naval District in Norfolk, Virginia, from 1940 to 1944. Ernest Sanders acquired the *Gypsy* around 1950. The image of the yacht at left was taken on Christmas Eve in 1951.

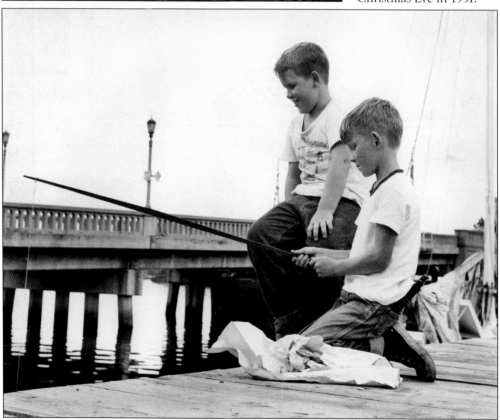

Two boys take up the simple pleasure of fishing from a dock near the Pasquotank River Bridge in this image, captured by photographer Jack Williams in 1952. Fishing, much like sailing, in northeastern North Carolina is a quiet recreational activity for some and a dedicated sport for others. Anglers take to the waters around Elizabeth City for the prospect of netting a multitude of catches, including largemouth bass, white perch, and red drum.

Depicted above are Captains Joel and Wilbur Van Sant posing for a picture taken around 1952 by photographer Jack Williams. Originally hailing from New Jersey, Joel F. Van Sant III and his nephew Wilbur T. Van Sant were seasoned mariners who both made a living on the open sea. Both men captained the pleasure craft of several wealthy patrons throughout their careers and traveled extensively. The two lived in Elizabeth City for a time and worked at the shipyard owned by the Sanders family; Wilbur would later come to serve as the company's president. Captain Joel's most notable claim was perhaps that of his design for the celebrated Moth boat. The trim yet sporty vessel quickly became a hit and soon led to the first interclub races in 1930. Both sailors were avid Moth boat enthusiasts and competed in many national and international regattas. In their later years, Joel and Wilbur retired to northeastern North Carolina, the elder Van Sant eventually being laid to rest in Elizabeth City.

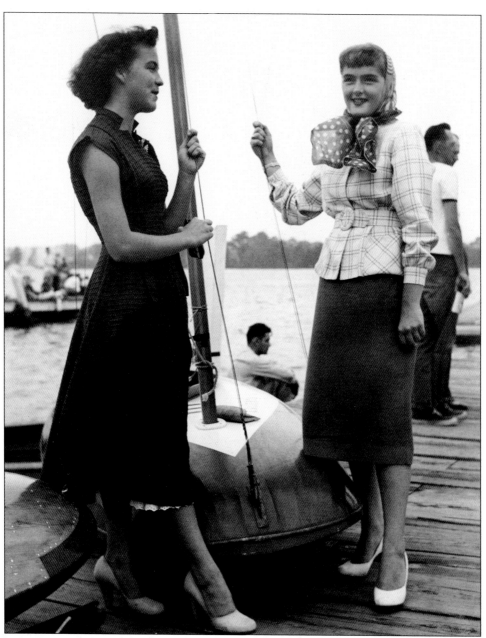

Elizabeth City High School seniors Shirley L. Leary, left, and Faye E. Coppersmith, right, pose for a picture with a Moth boat in this 1953 photograph by Jack Williams. Elizabeth City's Moth Boat Regatta and, later, Powerboat Regatta drew sizeable crowds with tens of thousands of spectators flocking from all around to attend. Smaller such races were occasionally scheduled in conjunction with the Albemarle Potato Festival, as was the case in 1953. During the last weekend in May that year, a crowd of some 50,000 to 75,000 visited Elizabeth City for food, fun, and festivities. A five-mile-long parade was planned as were contests, demonstrations, games, rides, and all sorts of activities for the big event. Shirley Leary and Ellen Coppersmith, both majorettes for the Elizabeth City High School Band, also participated in the State Baton Twirling Championship at the 1953 potato festival.

The image above depicts two sailors sitting at the stern of their skipjack in the Elizabeth City harbor. Skipjacks are the traditional sailing boats built and used for dredging oysters in and around the Chesapeake Bay. These shallow wooden craft were designated the official state boat of Maryland in 1985 and are known to be the last nonmotorized, commercial sailing vessels in North America.

The crew of the skipjack *Joyce* relaxes under sunny skies in this view from their push boat. Skipjacks generally sail by conventional means, using a push boat or yawl to navigate under windless conditions.

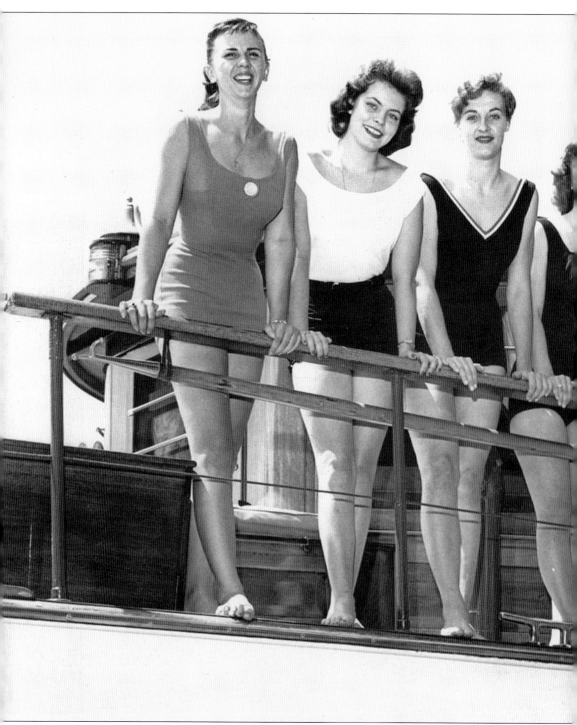

Here, a group of Elizabeth City High School students pose for a photograph aboard the *Doris II* in this image from around 1959. *Doris II* was the private yacht of Elizabeth City resident and Texas Oil Company distributor Miles L. Clark. Affectionately known as "Uncle Miles," Clark was a generous supporter of the Elizabeth City High School Band, committing his means to the growth

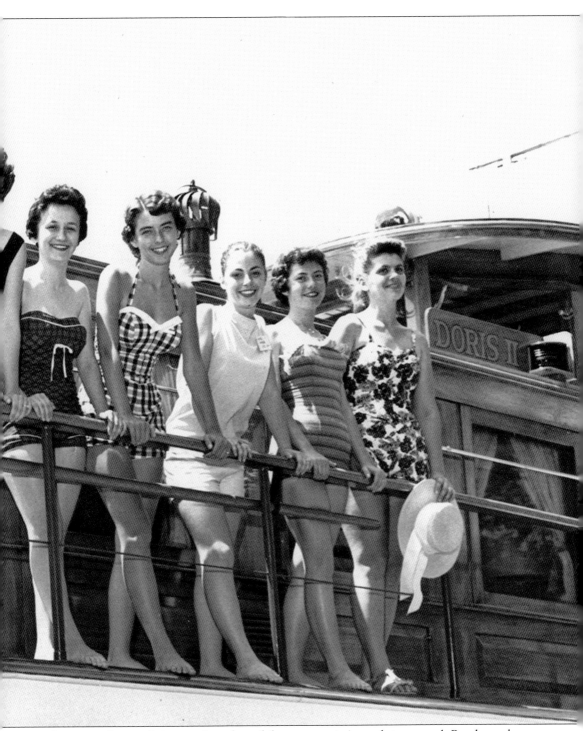

and success of not only its members, but of the community's youth in general. Band members, including majorettes and cheerleaders, were often invited out for cruises on his yacht. Many of the girls pictured here graduated with the class of 1959, including Barbara Hansen (second from left), Dianne Pritchard (fourth from right), and Castel Parker (third from right.)

Boaters take to the waters of the Pasquotank River during one of Elizabeth City's Powerboat Regattas in this photograph taken around 1954. By mid-century, as both inboard and outboard boat motors grew to become the modern means of propulsion in most watercraft, powerboats became all the rage for the excitement and spectacle they generated. Elizabeth City had hosted powerboat races since the start of the regattas in 1931, but the thrill for speed was so appealing that such races became ever bigger events on the Pasquotank by the 1950s. Visible in the background of this image is a barge with a large time clock on its bow. Timed speed trials were an essential part of these races as drivers competed to make the quickest and fastest course runs. While such races were well-attended and enjoyed for many years, Elizabeth City's annual Powerboat Regattas waned around the early 1970s.

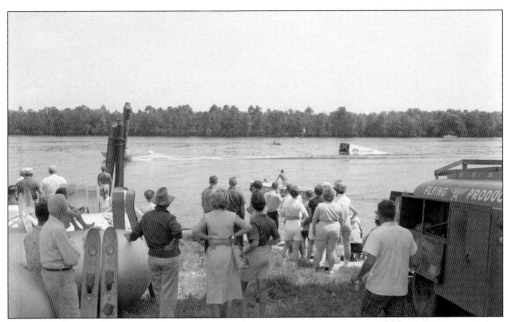

Spectators gather at the edge of the Pasquotank River to enjoy some incredible aquatic maneuvers performed during a water-skiing tournament in this image from June 10, 1960. The two-day event, hosted by the Pasquotank River Yacht Club, featured open competition among several expert skiers displaying their unique talents on the river. Some 50 skiers executed trick moves, airborne jumps, and barefoot skiing, wowing the crowd and helping promote further interest in the sport.

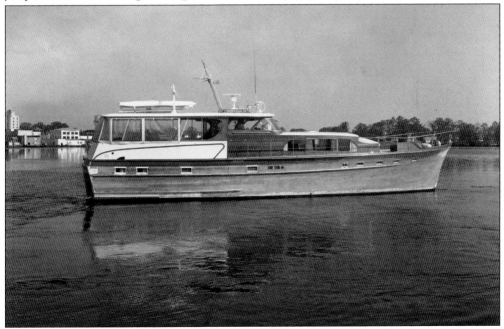

The 63-foot flush deck diesel yacht *Norsaga IV* cruises the Elizabeth City harbor in this picture from May 21, 1968. Built in 1962 by Broward Marine Inc. of Ft. Lauderdale, Florida, *Norsaga IV* was designed as a top-of-the-line showboat. She was first purchased by Col. C.M. Paul of Palm Beach, Florida. In 1969, her name was changed to the *Sybarite*.

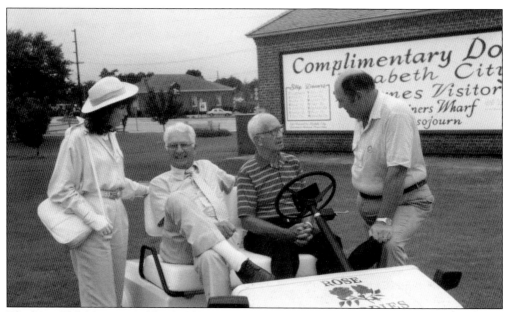

The legacy of the Rose Buddies holds a place of pride among Elizabeth City's cultural maritime traditions. This cordial custom began in September 1983 when lifelong friends Fred Fearing and Joe Kramer greeted arriving boaters with a warm welcome, a few simple snacks, and freshly clipped rose blossoms. Their endearing act soon caught the attention of Willard Scott, who paid the two a visit in August 1985 (above). The NBC-TV weatherman gifted them a golf cart, which became the pair's official "welcome wagon" and is now in the collection of the Museum of the Albemarle. The image below depicts Joe Kramer, left, and Fred Fearing, holding a wine jug, at one of their dockside parties at Mariners' Wharf on October 14, 1984. (Both, courtesy of Visit Elizabeth City.)

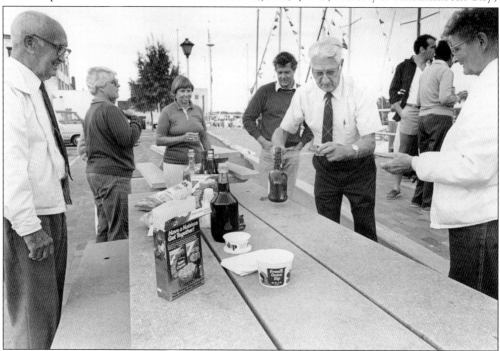

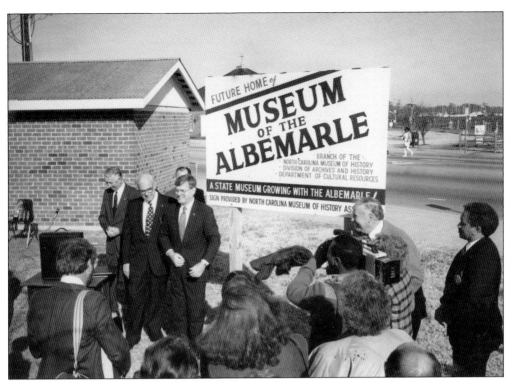

Established in 1967, the Museum of the Albemarle's continuing mission has been to interpret, collect, and preserve the cultural history of the Albemarle region of North Carolina. Initially located inside a former highway patrol station on US 17 South, plans to construct a more up-to-date facility began in 1988. The following year, the city council donated nearly two acres of land upon which the new museum would be built. The image above shows then North Carolina governor James G. Martin holding a press briefing near the future site of the Museum of the Albemarle on January 23, 1990. Pictured below is the museum at the corner of South Water and Ehringhaus Streets during its construction in August 2002.

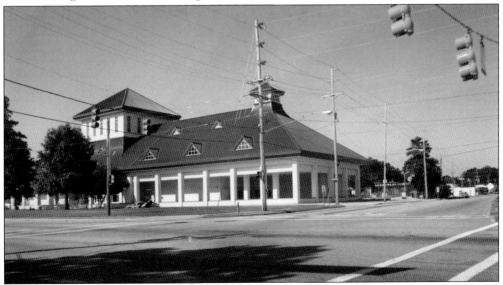

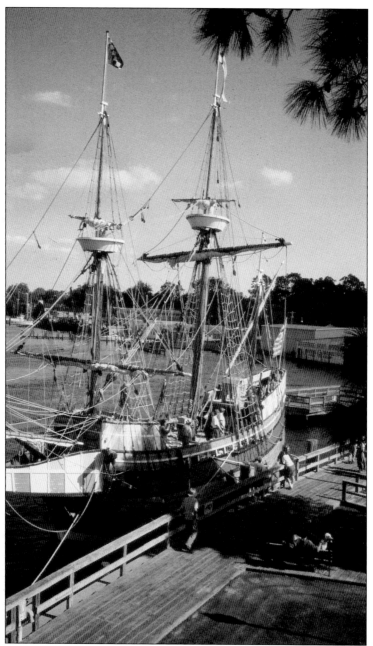

Built as a representation of the 16th-century sailing craft used by Sir Walter Raleigh to explore the New World, the *Elizabeth II* was named for one of the ships that made such a voyage in 1585. Plans to construct the vessel began in July 1982, ahead of the celebrations commemorating the 400th anniversary of Raleigh's Roanoke voyages. Launched in November 1983 and completed the following year, the *Elizabeth II* measured 69 feet in length and weighed 50 tons. She toured the Carolina coast on a two-week excursion in September 1985, sailing to the southern ports of Beaufort and Newbern. Today, anchored in her homeport of Manteo, the ship continues to serve as a living history attraction at the Roanoke Island Festival Park. The image above depicts the *Elizabeth II* docked at Waterfront Park during Elizabeth City's 1996 Classic Moth Boat Regatta.

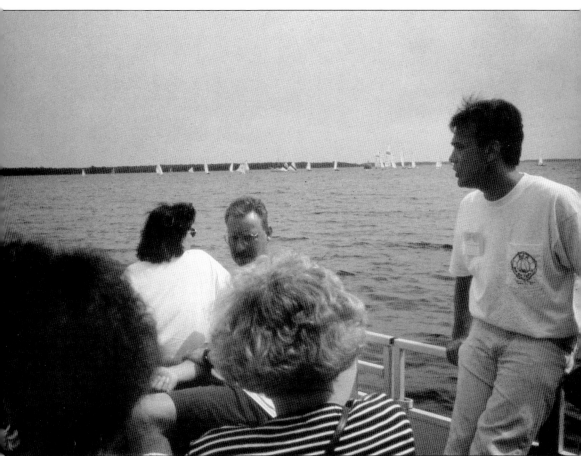

Museum of the Albemarle exhibit designer Don Pendergraft, at right, leads visitors on a historic boat tour along the Pasquotank River in this image taken at the 1996 Classic Moth Boat Regatta. Held on September 21, the regatta that year was promoted and organized with the assistance of the museum, offering guided tours of the races as well as the Elizabeth City waterfront. Today, the staff remains as supportive as ever of the Museum of the Albemarle's mission, providing insightful and engaging exhibits and programming to educate visitors on the history of North Carolina's Albemarle region. Pendergraft, who currently serves as the museum's director, continues to interpret the historical legacy of Elizabeth City and its surrounding communities. In a career spanning nearly 30 years with the North Carolina Department of Natural and Cultural Resources, he both advances and improves upon the founding mission set forth by the Museum of the Albemarle and its staff over 50 years ago.

Designated the official state historical boat of North Carolina in 1987, the shad boat saw widespread use as a sturdy fishing vessel in coastal waters primarily between Elizabeth City and Roanoke Island. The Wright shad boat, pictured above, was built in 1904 by Camden County resident and renowned decoy carver Alvirah Wright and acquired by the museum through a generous donation made by Alvirah's daughter-in-law Elizabeth Wright in 1996. Hanging from suspension cables inside the front lobby, the 1904 Wright shad boat remains one of the Museum of the Albemarle's largest and most prominent artifacts on display. On August 29, 2005, museum staff and volunteers transferred the Wright shad boat to the new museum building through downtown Elizabeth City by way of police escort. Facilities technician William Seymore, at center, stands next to the fully restored shad boat after its move. He remains a vital part of the museum staff with more than 20 years of dedicated service.

Four

SERVICE AND DEFENSE

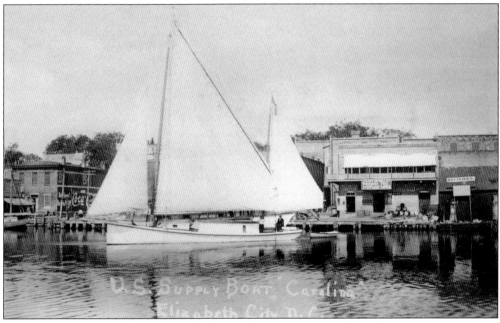

For generations, the citizens of Elizabeth City have committed themselves to a greater cause: contributing aid and relief in support of the homeland and the common good of its people. Branches of both the US Armed Forces and the federal civil service have called Elizabeth City home, including the US Life-Saving Service. Docked near the foot of East Main Street is a US government sharpie, the *Carolina*. During the early 20th century, she served as a supply boat for the several lifesaving stations in the region.

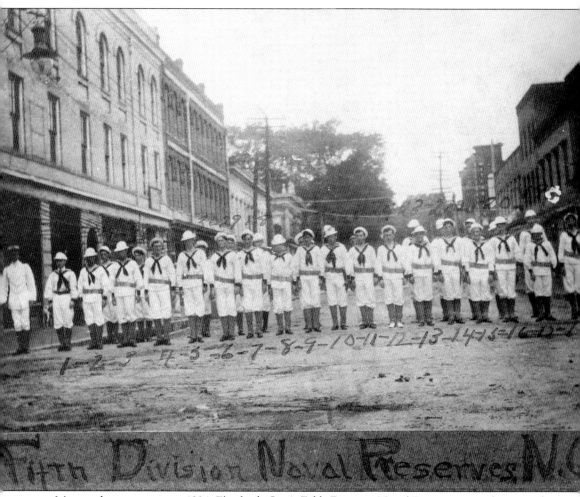

Mustered into service in 1894, Elizabeth City's Fifth Division Naval Reserves served as a ready volunteer force of the North Carolina Naval Militia. Headquartered in New Bern, the North Carolina Naval Militia consisted of no less than seven divisions, split into two battalions, stationed along the state's coastal regions. Depicted above are the officers and men of the Elizabeth City division standing at attention for this group photograph taken on June 7, 1908. Lt. Winfield A. Worth acted as the commanding officer of the Fifth Division during this time. Other Elizabeth City notables who served with the division include North Carolina governor J.C.B. Ehringhaus and Percy B. Ferebee. Ferebee (second row, far right) later moved to the western part of the state and became a prominent businessman and member of the North Carolina General Assembly from 1957 to 1959.

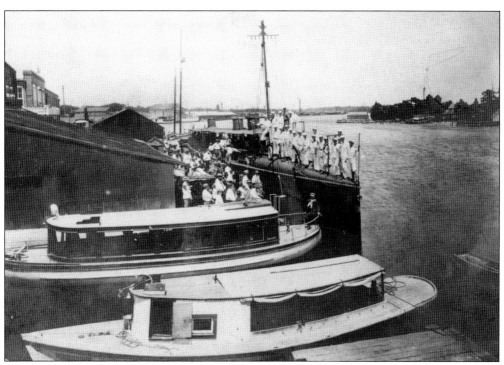

Launched in March 1897, a US Navy torpedo boat, the USS *Du Pont* (TB-7), was completed just prior to the Spanish-American War and carried dispatches while patrolling the waters around Key West, Florida, and Santiago, Cuba. A little more than a decade later, she was recommissioned as a training ship, serving the several divisions of reservists in the state of North Carolina. In July 1910, the Fifth Division Naval Reserves took command of the Porter-class torpedo boat shown above. During that summer, the Elizabeth City reservists sailed the *Du Pont*, conducting maneuvers and training exercises and making stopovers in ports such as Hertford, Washington, and Morehead City. Reserve crews with the North Carolina Naval Militia continued to train aboard the torpedo boat until the following spring. By October 1911, she was sent to the naval station in Newport, Rhode Island, until the start of the First World War. (Below, courtesy of the *Eastern Carolina News*, July 20, 1910, newspapers.com.)

Torpedo Boat Manned by Volunteers.

The first torpedo boat, equipped for war and manned from bridge to stoke-holes by volunteer forces, that ever left a North Carolina port, will sail from Elizabeth City port Sunday or Monday, July 24 or 25. The officers and men who will have this distinction are members of the Elizabeth City naval reserves, fifth division of North Carolina, and it will be a remarkable and creditable showing by the local company.

Two US Coast Guard personnel man a new rescue boat on the Pasquotank River in this image from 1940. In December 1939, the US Coast Guard began accepting bids to build a newly designed wood-hulled rescue boat. The Elizabeth City Shipyard won the bid to construct 10 of these craft at $2,700 per vessel. Measuring 30 feet in length and 9 feet wide, the new boats were equipped with Kermath Sea Wolf motors. This six-cylinder engine generated 225 horsepower and could make upwards of 30 miles per hour. By summer 1940, the first rescue boat was completed and sent out on the river for trial maneuvers on July 11. Naval architect Alfred E. Hansen, the craft's chief designer, was on hand to observe these initial test trials in Elizabeth City. He ultimately approved of the rescue boat's performance and commended the shipyard in its production.

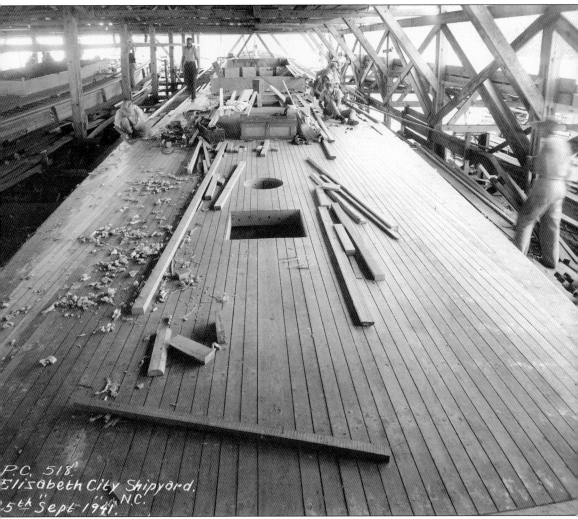

P.C. 518.
Elizabeth City Shipyard.
5th Sept 1941. N.C.

One of largest shipbuilding projects the Elizabeth City Shipyard undertook was in the production of thirty 110-foot US Navy subchasers. An article in the March 21, 1941, issue of the Raleigh *News & Observer* announced an initial $500,000 government contract awarded to the shipyard for the immediate construction of four such subchasers. Since the shipyard was a division of the Elizabeth City Iron Works and Supply Company, its facilities included a machine shop and forge. Much of the ship itself, including its propellers and shafts, was manufactured on-site. The image above shows workers planking and planing the deck of US Navy subchaser *PC-518* at the Elizabeth City Shipyard for service during the Second World War. *PC-518* was the fourth subchaser completed at the shipyard and was launched on November 12, 1941.

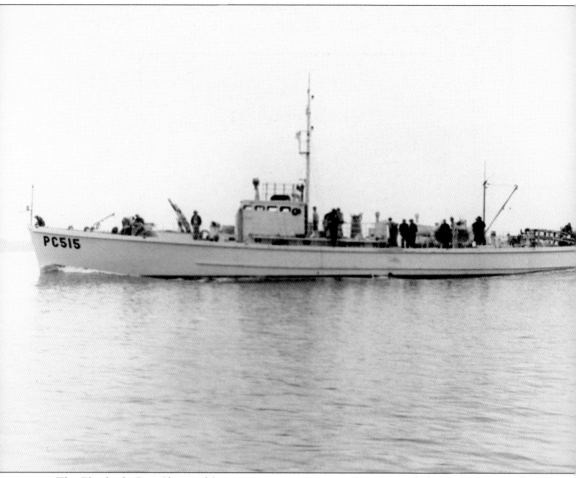

The Elizabeth City Shipyard began construction on its first four subchasers soon after being awarded the contract in early spring 1941. The keel for the first of these, US Navy subchaser PC-515, was laid on April 24, and work quickly progressed on the shipyard's first navy combat vessel. Five months later, PC-515 launched from the Elizabeth City Shipyard to great fanfare and praise. These early subchasers like PC-515 were originally given a "PC" designation to distinguish them from their First World War predecessors. However, in 1942, the 110-foot wooden-hulled ships were reclassified with the "SC" label. This change intended to differentiate them from the 173-foot steel-hulled patrol craft then in production. Thus, it is common to see subchasers built around this time marked with either the "PC" or "SC" letter prefixes.

𝔗𝔥𝔢 𝔈𝔩𝔦𝔷𝔞𝔟𝔢𝔱𝔥 ℭ𝔦𝔱𝔶 𝔖𝔥𝔦𝔭𝔶𝔞𝔯𝔡

is pleased to have as its guest

Miss Frances Cowell

at the launching of the

𝔑𝔞𝔳𝔶 𝔙𝔢𝔰𝔰𝔢𝔩 - 𝔓ℭ 515

September 20 1:00 P. M.

PLEASE PRESENT

Launched on September 20, 1941, *PC-515* became Elizabeth City Shipyard's first subchaser constructed under contract for the US Navy. Invited guests, including commandant of the Norfolk Navy Yard, Rear Adm. Felix X. Gygax, attended a brief launching ceremony that Saturday at the shipyard. In keeping with tradition, Joanne O'Malley of Norfolk christened the ship's prow with a bottle of champagne. The US Navy commissioned *PC-515* the following year in April 1942. On July 7, 1943, the subchaser rescued survivors of the American Liberty ship SS *James Robertson* following a German submarine attack off the coast of Brazil. The US Navy later transferred *PC-515* to France in October 1944 where she was reclassified as *CH-121*.

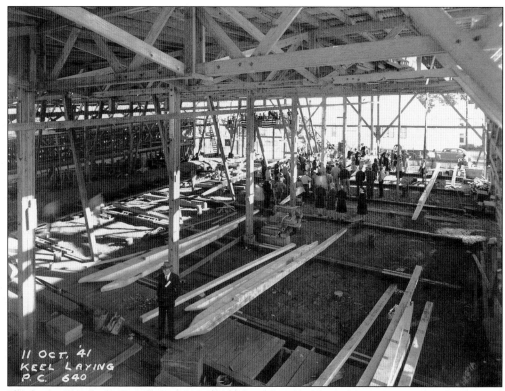

11 OCT. '41
KEEL LAYING
P.C. 640

While the Elizabeth City Shipyard steadily labored on building its first four subchasers, it soon accepted the option to construct an additional four. The keels of subchasers *PC-638* through *PC-641* were laid and the boats launched between 1941 and 1942. In the image above, a crowd gathers at the shipyard on October 11, 1941, to witness a special keel-laying ceremony for US Navy subchaser *PC-640*. Distinguished guests that day included North Carolina lieutenant governor Reginald L. Harris, Rear Admiral Gygax of the Norfolk Navy Yard, and Capt. Arthur W. La Touche Bisset of the British Royal Navy. Below, subchaser *PC-639*, at left, is shown tethered to her sister ship, *PC-638*, at the shipyard on New Year's Eve in 1941.

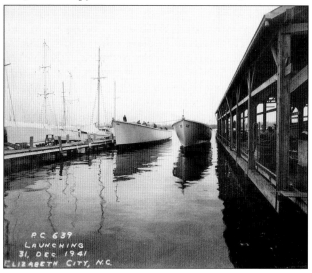

P.C. 639
LAUNCHING
31. DEC. 1941
ELIZABETH CITY, N.C.

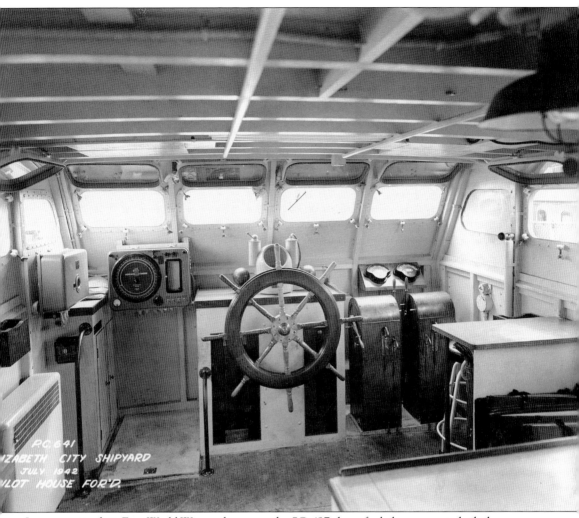

In contrast to their First World War predecessors, the SC-497 class of subchasers sported pilothouses built of strong cast aluminum rather than wood and came equipped with a greater array of sophisticated electronic gear. The image above depicts the interior of the forward pilothouse of US Navy subchaser PC-641. The rectangular device to the left of the ship's wheel is a fathometer manufactured by the Submarine Signal Company of Boston, Massachusetts. In the right-hand corner of the pilothouse stand the controls for the subchaser's two 8-268A Cleveland Diesel engines produced by General Motors. Commissioned on July 11, 1942, PC-641 served as an escort ship in the Pacific theater of the war. In March 1943, she sailed with a convoy of additional subchasers and other Navy vessels to the South Pacific islands. Following the war, she was transferred to the US Maritime Commission in March 1948.

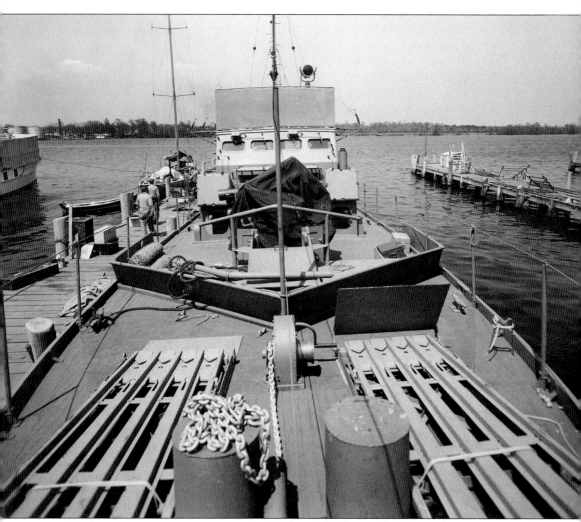

Depicted is a view from the forward deck of a US Navy subchaser moored at the Elizabeth City Shipyard. Situated near the bow of the ship, at the bottom of the image, are two sets of steel projector rails. These rails, nicknamed "mousetraps," launched 7.2-inch-diameter rocket-propelled depth charges. Each projector rail launched up to four of these rocket charges. Additional anti-submarine armaments generally equipped on US Navy subchasers included a 40-mm Bofors gun, three 20-mm Oerlikon cannons, and an optional twin 50-caliber machine gun. Two depth charge projectors, or "K" guns, mounted on either side of the ship near the stern, could launch 300 pounds of explosive charge up to 150 yards. Depth charge racks, also positioned near or at the stern, released additional charges directly into the water. Each subchaser usually carried 14 depth charges on aboard.

Here, crews are shown preparing US Navy subchasers *PC-640* and *PC-641* on July 7, 1942, at the Elizabeth City Shipyard for wartime service. Subchaser *PC-640* was commissioned on July 12, 1942, serving in the South Pacific by the following year. After the war, she, like her sister ship *PC-641*, was then transferred to the US Maritime Commission. Later sold as surplus, *PC-640* was converted into a fishing barge in 1951 for the Canadian Fishing Company of Vancouver, British Columbia.

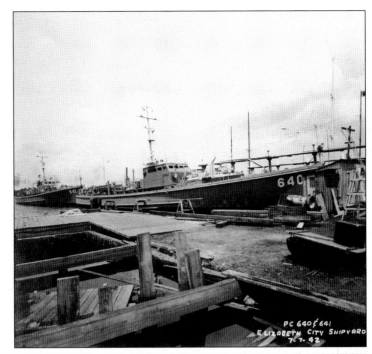

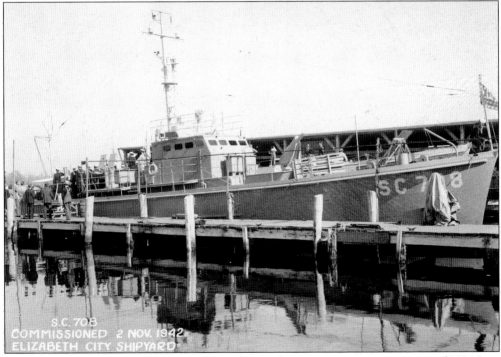

Sailors are seen here standing at attention during the commissioning ceremony of US Navy subchaser *SC-708* on November 2, 1942. Launched from the Elizabeth City Shipyard earlier that summer, *SC-708* later patrolled the waters along the North Atlantic coast; the subchaser and her crew made several stopovers at Naval Air Station Argentia in Newfoundland. After the war, in September 1947, she was transferred to the Republic of China.

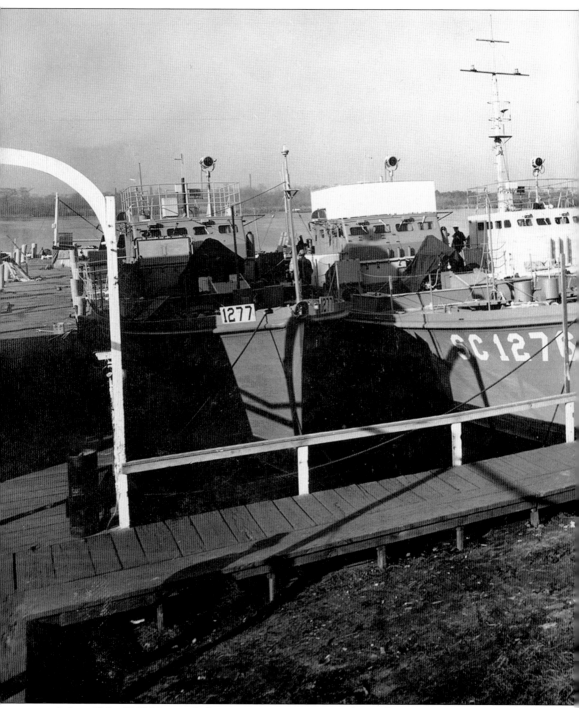

A handful of US Navy subchasers, in various stages of completion, are seen moored at the Elizabeth City Shipyard on February 22, 1943. The keels of *SC-1276* through *SC-1279* were all laid on September 7, 1942, and later commissioned in early spring 1943. On July 5, 1943, subchaser *SC-1279* rescued all hands aboard the American merchant ship SS *Maltran* following an attack from the German submarine *U-759*. After the war, *SC-1276*, *SC-1277*, and *SC-1279*

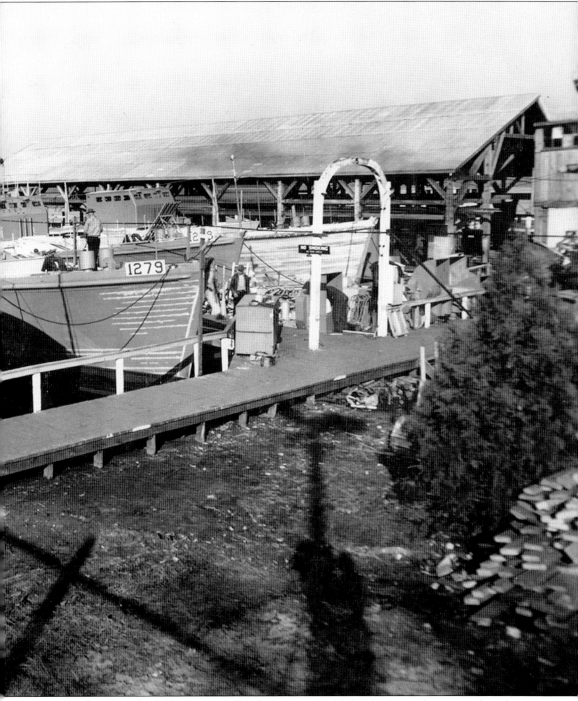

were transferred to the US Maritime Commission in 1946. *SC-1277* was later transferred to the US Coast and Geodetic Survey (USC&GS) and recommissioned as the USC&GS *Parker*. Reclassified as a landing control vessel in August 1945, the United States transferred *SCC-1278* over to the Philippines in July 1948.

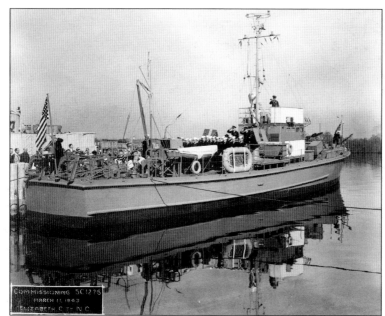

The officers and crew of *SC-1276* salute the American flag at the US Navy subchaser's commissioning ceremony on March 11, 1943. Lt. Comdr. Andrew S. Boyce, standing just to the left of the forward pilothouse, was the subchaser's first commanding officer.

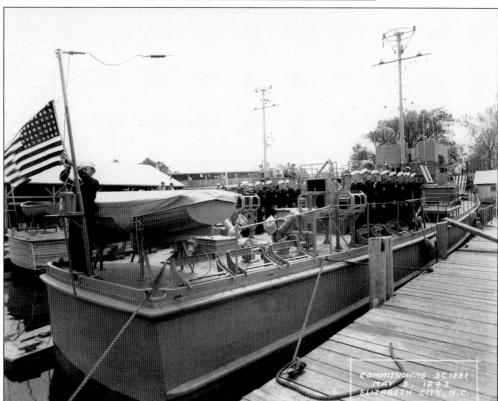

The crew of *SC-1281* stands at attention as a sailor hoists an American flag up the ship's stern flagstaff on May 3, 1943. *SC-1281* was another subchaser refitted as a landing control vessel, also in August 1945. She was transferred to the US Maritime Commission in December 1946. Note the depth charge racks along the starboard side of the ship.

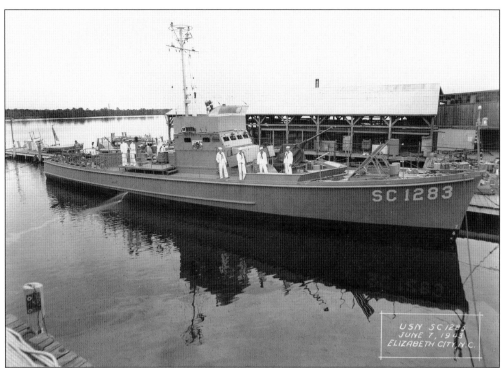

SC-1283 and SC-1286 were just two of nearly 80 subchasers transferred to the Soviet Union as part of President Roosevelt's lend-lease policy for assisting US Allied forces in the war effort. On July 13, 1943, Capt. B.V. Nikitin of the Russian Navy accepted SC-1283 on behalf of the USSR. An article in the July 14, 1943, issue of the *Miami Herald* covered the brief ceremonial transfer held at the Submarine Chaser Training Center in Miami. SC-1283 and SC-1286 were reclassified as BO-201 and BO-204, respectively. In the image below, the officers and crew of SC-1286 can be seen saluting during the US Navy subchaser's commissioning ceremony on July 21, 1943.

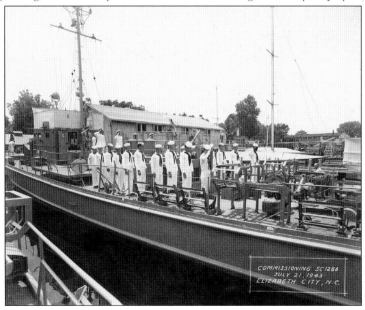

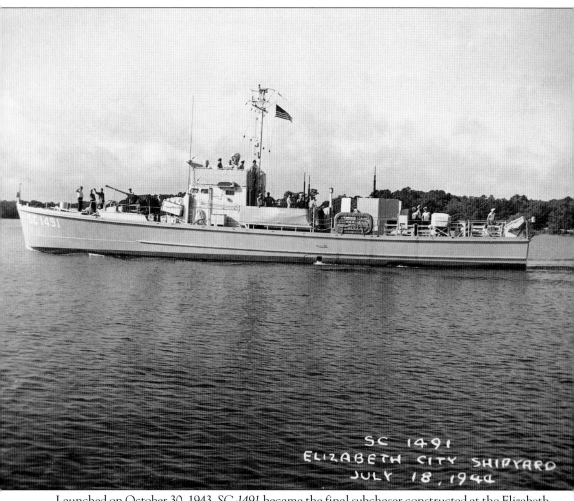

SC 1491
ELIZABETH CITY SHIPYARD
JULY 18, 1944

Launched on October 30, 1943, *SC-1491* became the final subchaser constructed at the Elizabeth City Shipyard. Built on government contract with three additional subchasers, *SC-1488*, *SC-1489*, and *SC-1490*, the production cost for all four vessels came to $512,000. Commissioned on July 15, 1944, the image above depicts the ship and her crew prior to embarking north for Norfolk, Virginia. *SC-1491* then sailed for Miami and was decommissioned there a month and a half later. On August 30, 1944, she was transferred to the Soviet Union and reclassified as *BO-237*. Remaining in Soviet service for over a decade, the subchaser was finally scuttled in the Barents Sea in June 1956.

In March 1943, the Elizabeth City Shipyard was awarded another wartime government contract for the construction of four US Navy tugboats. The first of these Cahto-class harbor tugs to be built was the USS *Kabout* (YTB-221). Several shipyard workers can be seen preparing the ship's keel early in the harbor tug's construction in this image from May 26, 1943. Note the freighter *Hattie Creef* dry-docked in the background.

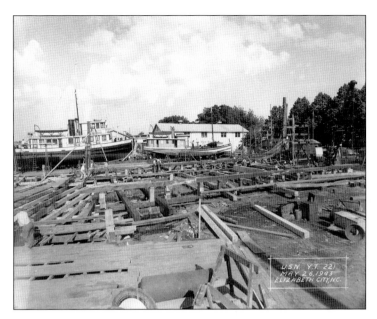

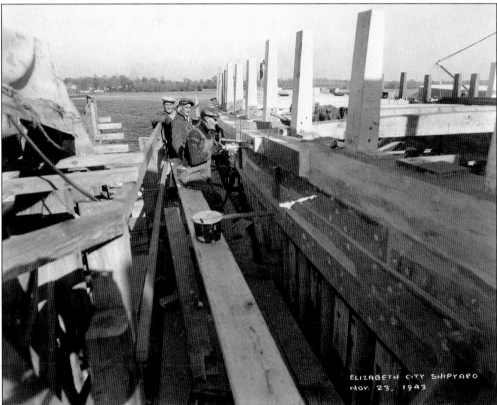

Here, laborers work on the hull of one of the harbor tugs at the Elizabeth City Shipyard on November 23, 1943. When construction on the tugs began that year, the shipyard was already managing a workforce of some 600 employees. The total labor time estimated in the production of just one of these tugs was around 165,000 hours.

Andrew Sanders sits behind the rudder of one of the large harbor tugs in this photograph from December 9, 1943. During the war, the Sanders brothers continued to oversee the Elizabeth City Shipyard in their various executive and administrative rolls. Andrew Sanders served as chairman of the board of directors for the company, Ernest Sanders served as president and general manager, Archie Sanders served as vice president and plant superintendent, and Henry Sanders served as secretary, treasurer, and purchasing agent.

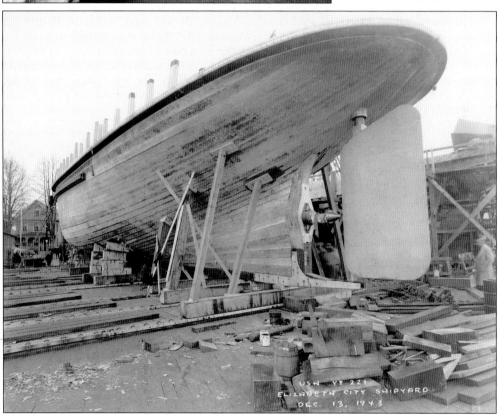

The completed hull of the *Kabout* sits in dry dock in this image from December 13, 1943; she would be launched at the shipyard just two days later. Built for harbor and coastal work and to serve in a general utility capacity, these ships were all reclassified as large harbor tugs (YTB) in May 1944. They measured 110 feet in length with a draft of almost 11.5 feet.

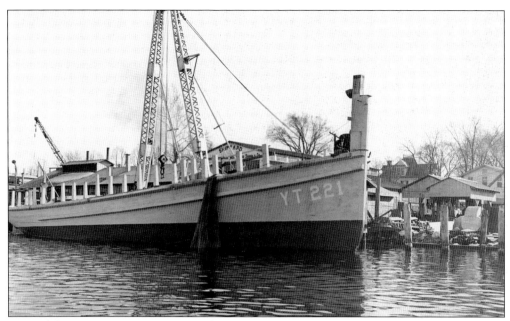

Derived from a Native American word meaning "canoe," the US Navy harbor tug *Kabout* was launched from the Elizabeth City Shipyard on December 15, 1943. Later placed into service in July 1944, the *Kabout* was sent north to serve with the Fifth Naval District, in Norfolk, Virginia. In early February 1946, she sailed for New York Harbor to assist in an emergency capacity amid growing tensions among striking New York City tugboat workers. The Navy harbor tug's service with the Fifth Naval District ended in May 1959, and the *Kabout* was subsequently struck from the Naval Register. She was later sold in August that year.

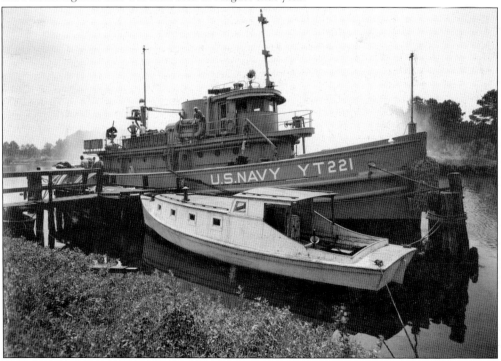

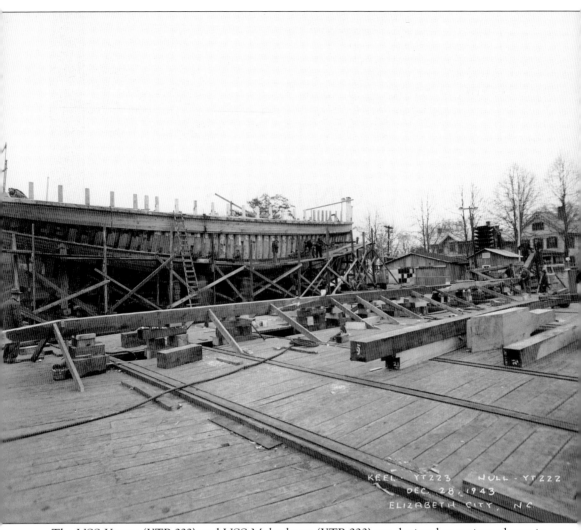

KEEL - YTZ23 HULL - YTZZ2
DEC. 28, 1943
ELIZABETH CITY N.C.

The USS *Kasota* (YTB-222) and USS *Mahackemo* (YTB-223) are depicted at various phases in their construction at the Elizabeth City Shipyard in this photograph from December 28, 1943. In the background sits the uncompleted hull of the *Kasota* and in front is the recently laid keel of the *Mahackemo*. Just one harbor tug required thousands of board feet of lumber to build. Their production included various kinds of wood, too, such as white pine, juniper, and cypress. They also required parts from over 160 suppliers across the country. The build cost for a Navy harbor tug like the *Kasota* or the *Mahackemo*, including labor, came to almost $314,500.

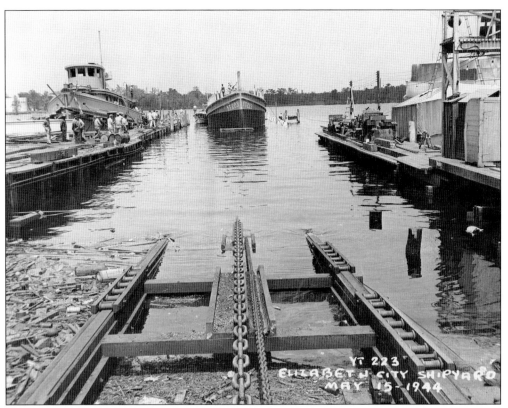

The Elizabeth City Shipyard launched the US Navy harbor tug USS *Mahackemo* on May 15, 1944. Katherine M. McCracken, shown at right, attended the launching ceremony that day as sponsor of the ship. Her husband, Joseph G. McCracken, served as principal of Elizabeth City High School. Placed into service on October 30, 1944, the *Mahackemo* was assigned to the Fifth Naval District in Virginia. Between April and June 1946, the tug was sent north to Pennsylvania, most likely to aid amid the ongoing tugboat workers strike in Philadelphia around that time. Upon her return, the *Mahackemo* was reassigned to the Sixth Naval District and eventually placed out of service in August that year. She was ordered back to active duty two years later, but while being towed to Newport, Rhode Island, the tug foundered and sank off Cape Hatteras on September 11, 1948.

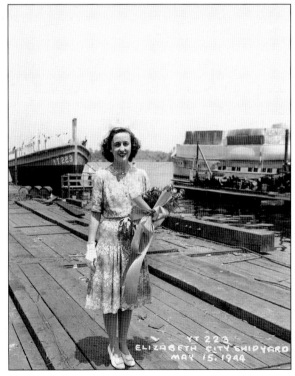

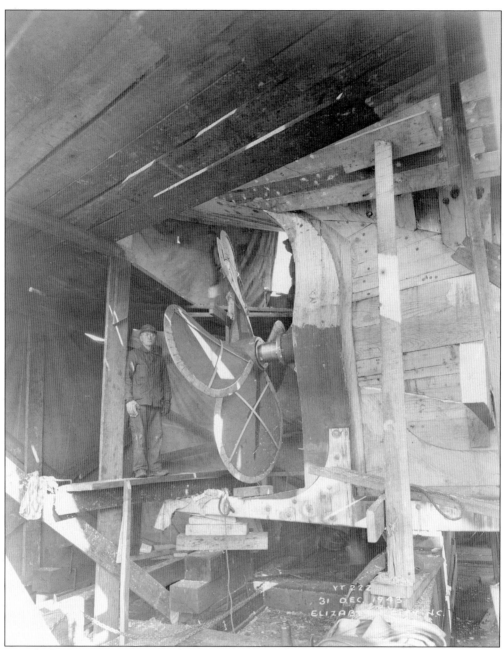

An Elizabeth City Shipyard worker stands beside the USS *Kasota*'s screw prop in this image taken on New Year's Eve in 1943. Essential as it was to meet the US Navy's wartime demands, these ships were fitted with heavy-duty machinery and equipment. Each harbor tug's power plant consisted of a marine diesel engine furnished by the Enterprise Engine and Foundry Company of San Francisco. The eight-cylinder, four-cycle motor produced 1,000-shaft horsepower, powering the tug's single, large-diameter, low-speed propeller. A reduction gear and propulsion motors, supplied by the Westinghouse Electric Company, contributed to the tug's overall speed of 12 knots. The *Kasota* entered service with the Fifth Naval District in Norfolk, Virginia, in September 1944. She served the naval station there for 15 years, finally being deactivated in May 1961.

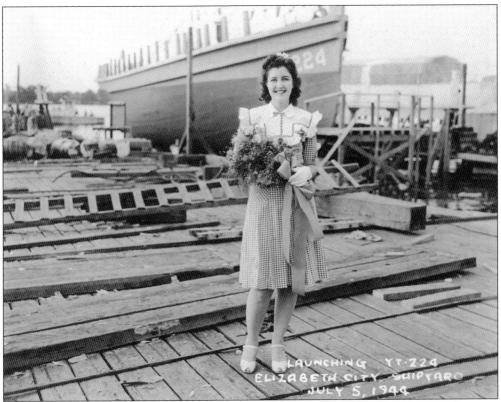

The last of the four Navy harbor tugs to be launched at the Elizabeth City Shipyard was the USS *Manada*. Above, Virginia F. Liverman of Elizabeth City acted as sponsor of the tug at the launching ceremony on July 5, 1944. The *Manada* went into service later that December and performed tug and general utility duties across the country for the next decade. First serving in Norfolk, she was transferred to the Sixth Naval District in Charleston, South Carolina, in June 1946. The harbor tug further served naval operations in Texas, the Great Lakes area, and Florida before her service ended in January 1954.

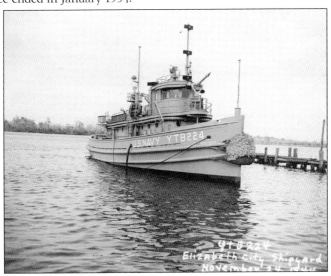

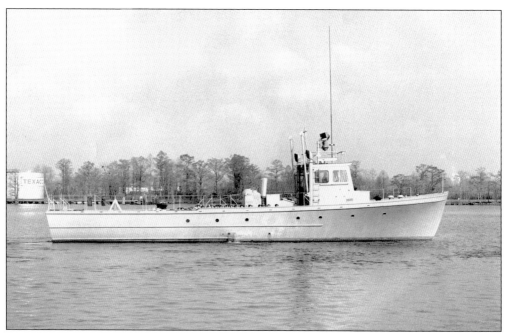

In June 1957, the Elizabeth City Shipyard won a contract to build torpedo retrievers for the US Navy. The contract awarded the shipyard to build three Mk-2 retrievers at a cost of $583,000. These 72-foot craft were responsible for recovering and servicing practice torpedoes used for undersea training exercises. The Mk-2 retriever sported an enclosed pilothouse and carried a crew of six. Powered by two 500-horsepower diesel engines, these boats could make a swift 18 knots.

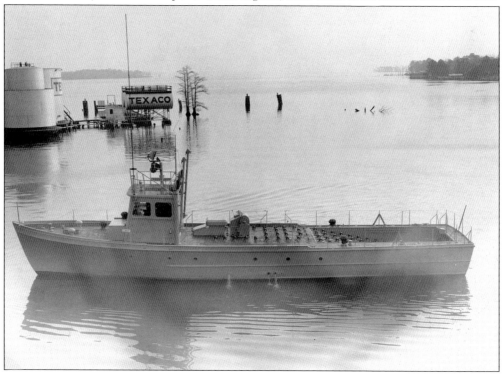

Five

SPORT

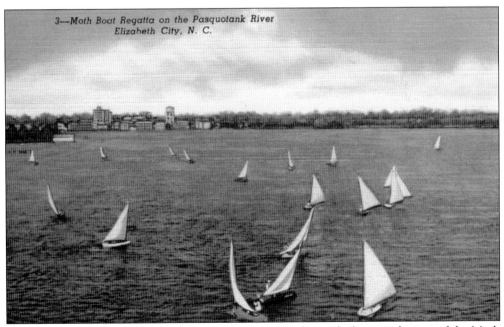

Competitive sailing in Elizabeth City soared to new heights with the introduction of the Moth boat in 1929. Joel Van Sant designed and built the sleek little craft with the help of Ernest Sanders and Harry O'Neal. The first interclub races were held the following year, and soon, Elizabeth City's Moth Boat Regatta was born.

Capt. Joel F. Van Sant III of Hammonton, New Jersey, was an ardent sailor and spent most of his life on the water. Featured in several sailing magazines like *Motor Boating*, *The Rudder*, and *Yachting*, he was commonly referred to as the "Father of the Moth Boat." Van Sant's original Moth boat, *Jumping Juniper*, was built at the Elizabeth City Shipyard and placed second in the annual Moth boat races held in 1931. He would later go on to win the coveted gold Antonia Trophy in 1936. The skipper later settled in Elizabeth City and wrote extensively on the waterways in and around North Carolina. Captain Van Sant was an integral figure in Elizabeth City's rise as a prominent locale for the several national and international regattas the city hosted starting in 1933.

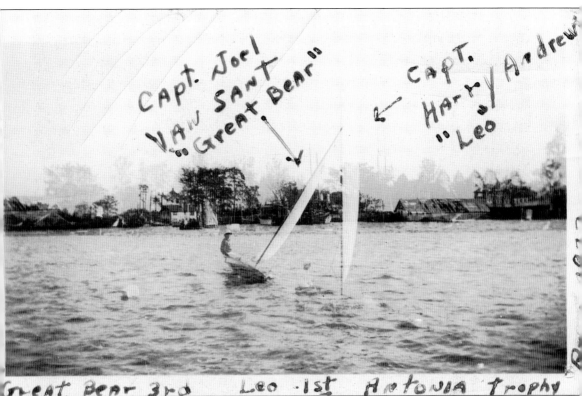

Capt. Joel Van Sant "Great Bear"

Capt. Harry Andrews "Leo"

Great Bear 3rd Leo 1st Antonia Trophy

Following the Moth boat's introduction, interest in the little sailing dinghy grew to such an extent that a national association for this new class of boat formed in 1932. In 1933, the association sponsored the first annual National Moth Boat Regatta, which was held in Elizabeth City during the second weekend in October. Capt. Harry Andrews took first place in the national championship race and won the Antonia Trophy race. The image above is a superimposed photograph of both Joel Van Sant and Harry Andrews piloting their respective Moth boats at the 1933 national regatta in Elizabeth City. Van Sant placed third in the world championship race that year with his entry, *Great Bear*.

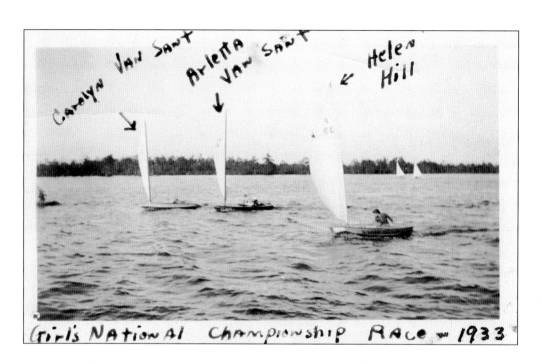

Here, sisters Carolyn and Aleta Van Sant of Atlantic City, New Jersey, and Helen Hill of Elizabeth City compete in the girls' championship race at the 1933 National Moth Boat Regatta. The Van Sant sisters were the daughters of Capt. Joel Van Sant and, like their father, competed in several Moth boat championships. Below is a membership card issued by the Pasquotank River Yacht Club to Ann Wilcox of Elizabeth City. The Pasquotank River Yacht Club incorporated in September 1931, hosting what would become its first annual regatta the following month with the Evening Star Yacht Club of Atlantic City, New Jersey. Featured on the card is the club's distinctive tricolor burgee in the background.

Pasquotank River Yacht Club

Elizabeth City, N. C.

This is to Certify that _Ann Wilcox_

is a member in good standing and entitled to all courtesies of the club.

Good until _September 22_, 19 3 4

Millicent Sanders _Helen Hill_

COM. SEC'Y.

E-7080

This undated postcard features a "moth-type boat" with two men, one wearing a skipper's cap and the other holding a trophy, on the waters near Elizabeth City. The vessel pictured here is likely a reference to the Moth boat that Allan Hayman and Jack Gard piloted in the 1930s. Allan Hayman was the son of Thomas B. Hayman, owner of a boatbuilding shop on Riverside Avenue. In June 1934, Hayman and the young Gard entered their Moth boat, Memory, into the Elizabeth City-Roanoke Island Moth Marathon, sponsored by the Pasquotank River Yacht Club. Considered as more of an endurance test than a race, the Memory placed first out of seven entries competing that day; only three completed the course. Due to the less than favorable wind conditions, it took the two sailors almost 20 hours to reach Manteo from Elizabeth City.

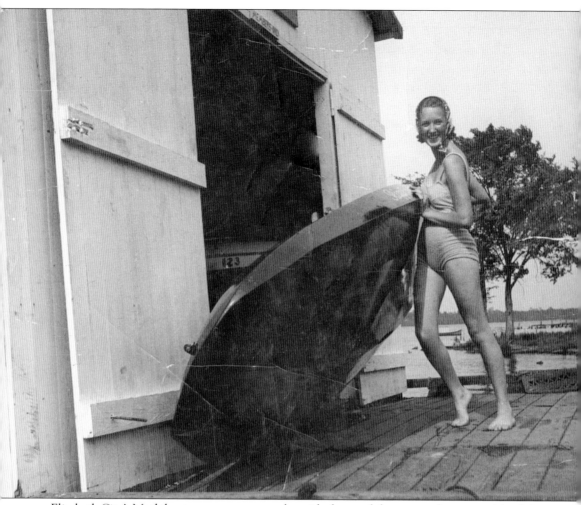

Elizabeth City's Moth boat races were as popular with the youth boaters as they were with adults. During the 1937 National Moth Boat Regatta, 15-year-old Aleta Van Sant beat out 18-year-old Violet Cohoon, shown above holding *Rippling Rhythm*, to win the girls' national championship that year. Nevertheless, Cohoon, a skilled Elizabeth City sailor, won many principal Moth boat titles, including the girls' 1936 South Atlantic States Championship and the girls' world championship in 1937. Moreover, 15-year-old Elizabeth City native Roscoe Stevenson Jr., who won the boys' national championship in 1937, went on to win the Antonia Trophy at the International Moth Boat Regatta held in Atlantic City, New Jersey, in 1948.

Schedule of Racing Events

————o————

FRIDAY, OCTOBER 15th

Girls' South Atlantic States Championship............................ 9:00 A. M.
Boys' South Atlantic States Championship........................10:30 A. M.
(Under 16 Years)
First Heat—Four—Moth Team Inter-Club Trophy Race.............12:30 P. M.
(Four Moths from Any Club or Division)
Second Heat—Four—Moth Team Inter-Club Trophy Race........ 2:30 P. M.
First Heat—Selig's Gold Cup Challenge Race.................... 4:30 P. M.
(Two Moths from Any Club or Division)
Annual Meeting of International Moth Class Assn........................ 7:30 P. M.
(Pasquotank River Yacht Club)

————o————

SATURDAY, OCTOBER 16th

Final Heat—Four—Moth Team Inter-Club Trophy Race.............. 9:00 A. M.
Final Heat—Selig's Gold Cup Challenge Race....................11:00 A. M.
Girls' National Championship.. 1:00 P. M.
Boys' National Championship.. 2:45 P. M.
(Under 16 Years)
South Atlantic States Open Championship........................ 4:30 P. M.
Dance—Elizabeth City Country Club...........................10:00 'til 2

————o————

SUNDAY, OCTOBER 17th

Winston Smith Memorial Trophy Race............................11:00 A. M.
North Carolina Governor's Cup Race............................12:30 P. M.
(State Championship—Open)
National Open Championship.. 2:00 P. M.
Hampton One Design Race.. 2:30 P. M.
Presentation of All Trophies—Pasquotank River Yacht Club..... 5:30 P. M.

NOTE: Between 2:00 and 2:30 P. M. special races will be started for any
sailing class with three or more entrants. These races will be held on a
different race course from the one used for Moth Races.

*Free lunches will be served entrants and their guests during the
three days of racing.*

————o————

Depicted above is the racing schedule from the 1937 National Moth Boat Regatta. Held in Elizabeth City that year, the regatta featured three days of races on the Pasquotank River, including team and youth competitions. The Florida East Coast Yacht Club of Miami won the Moth Team Inter-Club Trophy Race, beating out the Evening Star and Pasquotank River Yacht Clubs for first place. New Jersey native Charlie H. Higgins Jr. won the Winston Smith Memorial Trophy Race with his entry, the *Susie Q.* Winston Smith, the young sailing enthusiast for whom the race honored, had been killed in an automobile accident while on his way to Elizabeth City two years prior. The 16-year-old from Miami, Florida, was en route to compete in the 1935 National Moth Boat Regatta when the car he was riding in wrecked in Marion, South Carolina, on October 17. He was just nine days shy of his 17th birthday, and the crash occurred a day before the start of that year's regatta.

THE 1940
INTERNATIONAL MOTH BOAT REGATTA

Held in Conjunction With

THE TENTH ANNIVERSARY REGATTA
——of the——
PASQUOTANK RIVER YACHT CLUB

Elizabeth City, North Carolina
October 18, 19, 20, 1940

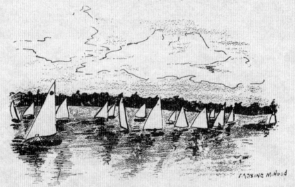

Regatta Scene — Elizabeth City, N. C.

Sanctioned by The International Moth Class Association
Sponsored by The Pasquotank River Yacht Club

The year 1940 was a big one for the Moth Boat Regatta as the annual event first kicked off with the dedication of the new US Coast Guard Air Base in Elizabeth City. As a regular supporter of these annual races, the Coast Guard was instrumental in officiating competitions and ensuring boater safety on the river. Its new air base was dedicated on Thursday, October 17, a day before the start of the regatta. The ceremony included public addresses given by Elizabeth City mayor Jerome B. Flora and military officials as well as aerial demonstrations and a concert performance by the Elizabeth City High School Band. On October 18, the first day of races proved challenging as gale-force winds, averaging 30 miles an hour, made the course difficult for participants to sail. The evening's festivities convened in the Virginia Dare Hotel where Chick Ciccone and his orchestra played at the annual regatta dance.

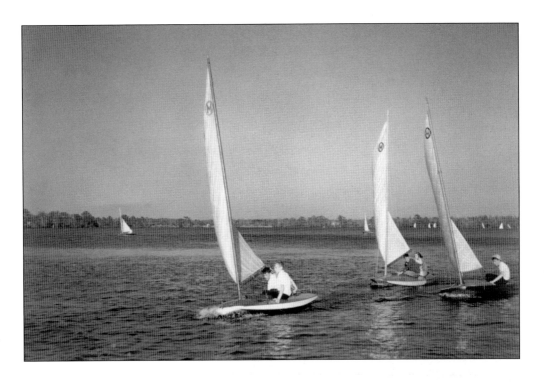

Here, young sailors vie for lead position in a junior championship race, shown above, during the 1940 International Moth Boat Regatta. Elizabeth City native Edward C. Gasch, representing the Pasquotank River Yacht Club, won the Junior International Moth Championship with his entry, *Lucky*. Aleta Van Sant won both the Girls' National and International Moth Championships as well as the National Open Moth Championship that year, beating out 30 other veteran skippers in her craft *Stormy*. Twenty-two-year-old Charles W. Stadler of Millville, New Jersey, took first place in the World's Open Moth Championship, winning the gold Antonia Trophy. Stadler completed the race in 3 hours and 20 minutes in his boat *Sweetheart*.

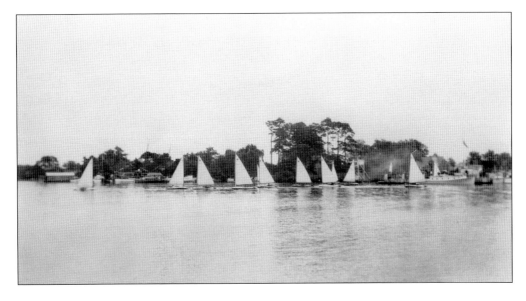

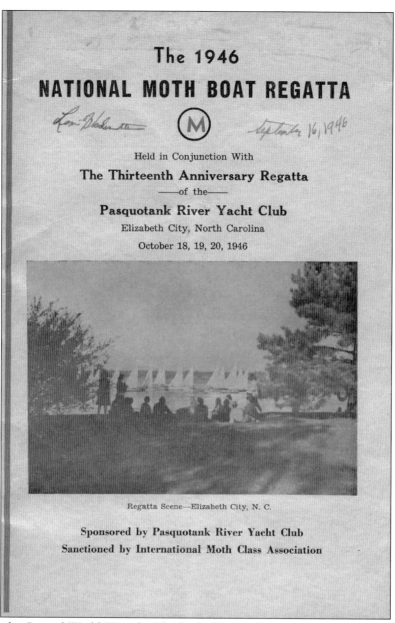

The 1946
NATIONAL MOTH BOAT REGATTA

Ⓜ

Lou Bladett *September 16, 1946*

Held in Conjunction With

The Thirteenth Anniversary Regatta
——of the——

Pasquotank River Yacht Club
Elizabeth City, North Carolina

October 18, 19, 20, 1946

Regatta Scene—Elizabeth City, N. C.

Sponsored by Pasquotank River Yacht Club
Sanctioned by International Moth Class Association

Following the Second World War, the Elizabeth City Moth boat community saw a return to the championship races it once regularly hosted with the 1946 National Moth Boat Regatta. Between 1942 and 1945, no races were held for the National Open Moth Championship or the world's championship. The Pasquotank River Yacht Club held a Victory Regatta the year prior, in 1945. Now with the war over, a resurgence in the excitement and competitive spirit of Moth boat sailing took hold. The 1946 national regatta brought to Elizabeth City sailors from as far away as Connecticut. Capt. Joel Van Sant, piloting *Gretchen*, took home the first postwar National Open Moth Championship. Russell B. Post of Atlantic City, New Jersey, won the Antonia Trophy in the world's championship race. Twenty-year-old Marguerite "Peggy" Kammerman, also of Atlantic City, won the Girls' National Moth Championship; she placed second, behind Joel Van Sant, in the National Open Moth Championship.

The International Moth Class Association, reorganized from the National Moth Boat Association in 1935, acted as the official governing body for all things related to the Moth boat. Elizabeth City served as the national headquarters for this organization during its early years. The association provided its members with valuable information, from the regulatory specifications for competing craft (right) to the latest Moth boat news developing both nationally and internationally. The association drew up its own constitution and bylaws, held annual meetings, elected officers, and conducted business in the pursuit of promoting the Moth boat for recreation as well as sport.

MOTH SPECIFICATIONS

The Moth Boat is not to be considered a one-design class but it is the intention and will of the International Moth Class Association that the designer and builder be given the fullest liberty in design and construction in order to develop and produce faster Moths.

1. HULL:

 Not more than 11 feet over all.
 Not more than one rudder.
 Not more than one center board.

2. CONSTRUCTION: No restrictions on design or construction.

3. SPARS: All spars shall be straight.

 a. Mast: Not more than one. Length: not more than 16½ feet above deck. Diameter: Not more than 3½ inches.

 b. Boom: Not more than one. Length: Not more than 9½ feet. Diameter: Not more than 3 inches.

 c. The angle of the mast and boom to be not more than 90 degrees.

 d. Sail limitation marks ¾ inches in width, 15 feet between markings must be placed on mast with top of lower

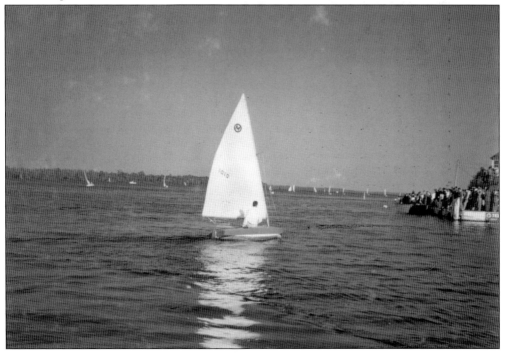

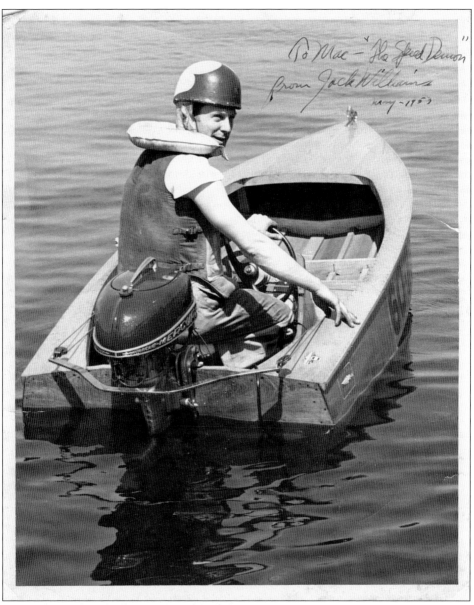

Powerboat enthusiast Charles F. McNaughton Jr. poses in his outboard racer, *Hi-Spray*, in this photograph taken by Jack Williams in May 1953. Born in Millerstown, Pennsylvania, in 1925, McNaughton served in the Second World War and later settled in Elizabeth City with his wife, Frances. Already racing competitively by the late 1940s, he began organizing powerboat races in Elizabeth City in 1950. Several races were organized under his direction that year with the hopes of stirring interest in the sport. Like the Moth boat, popularity in powerboat racing soon grew and spectators came by the thousands to view the competitions. Outboard motorboat races were scheduled as part of the 1950 National Moth Boat Regatta held in October. The following year, the Pasquotank River Yacht Club sponsored a two-day Powerboat Regatta, held in conjunction with the annual potato festival, during the last weekend in May. McNaughton, along with other power racing enthusiasts such as Russell Twiford and J.P. Forehand, would continue to promote and support Elizabeth City's powerboat racing community well into the 1960s.

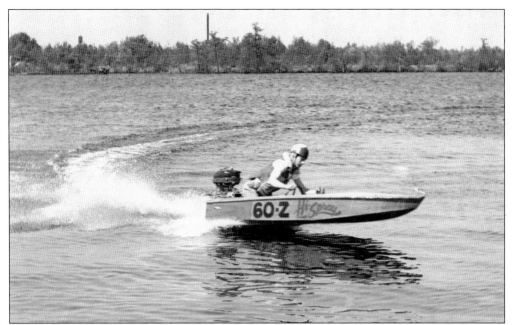

Charles F. McNaughton Jr. zooms around the Pasquotank River in his racer, *Hi-Spray*, shown above, in this image taken by Jack Williams. In May 1953, the Pasquotank River Yacht Club sponsored the third annual Powerboat Regatta, which was held in conjunction with that year's Albemarle Potato Festival. Sanctioned by the American Power Boat Association, officials entered some 150 inboards and outboards for the big two-day event. Competitors from New York to Florida met on the Pasquotank River to run the 2.5-mile course. The photograph below depicts McNaughton inspecting his two trailered outboards, *Peggy* and *Southern Yankee*, in 1955. During this time, he owned and operated McNaughton Outboard Motors, a marine engine and supply business in Elizabeth City.

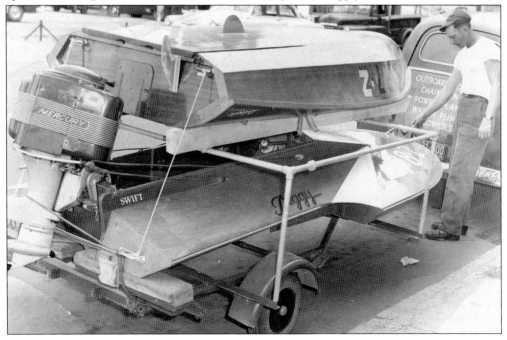

Elizabeth City's powerboat racing community achieved something of a milestone in 1954 with the International Cup Regatta. An even bigger event than those held just years prior, the International Cup Regatta brought some of the fastest boats in the country to race on the Pasquotank River. Scheduled for the first weekend in October, the two-day event included the Unlimited class of powerboats competing for the International Cup Trophy, shown above. An article in the September 30, 1954, issue of the *Belhaven Pilot* described the Unlimited class as "the glamour girls of racing on water." These heavyweight hydroplane contenders cost anywhere between $100,000 and $250,000 to fabricate and maintain. Usually powered by the Allison V-1710 twelve-cylinder engine, such power plants were produced during the Second World War for use in aircraft like the P-51 Mustang. Unlimited class entries in the International Cup Regatta that year included Joe Schoenith's *Gale V* (U-55) and Horace Dodge's *Dora My Sweetie* (U-14).

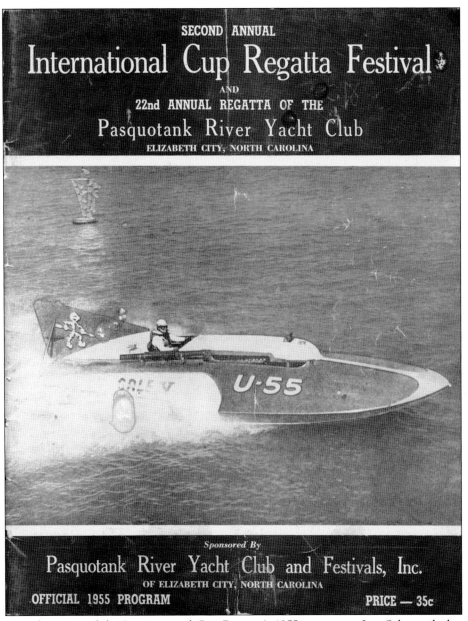

SECOND ANNUAL

International Cup Regatta Festival

AND

22nd ANNUAL REGATTA OF THE

Pasquotank River Yacht Club

ELIZABETH CITY, NORTH CAROLINA

U-55

Sponsored By

Pasquotank River Yacht Club and Festivals, Inc.

OF ELIZABETH CITY, NORTH CAROLINA

OFFICIAL 1955 PROGRAM PRICE — 35c

Gracing the cover of the International Cup Regatta's 1955 program is Lee Schoenith driving the *Gale V*. Schoenith's *Gale V* returned to the 1955 International Cup Regatta as the defending champion. In 1954, he placed first in the second heat with a top speed of nearly 94 miles per hour. A crowd of some 40,000 onlookers was in attendance for Elizabeth City's second year of these races at the beginning of October. Seven entries in the Unlimited class competed for the International Cup Trophy in 1955, including Frank Saile Jr.'s *Miss Wayne* (U-50) and George Simon's *Miss U.S. I* (U-2). However, it was Guy Lombardo's *Tempo IV* (G-13) that clenched the victory in Elizabeth City that year with driver Danny Foster setting a new course record of 105 miles per hour. The famed orchestra leader's team took home the $2,500 International Cup Trophy, which was awarded by the Elizabeth City Chamber of Commerce. The Museum of the Albemarle currently retains the regatta trophy in its collection.

The International Cup Regattas of the mid-1950s were likely the biggest sporting events the Harbor of Hospitality has ever hosted. The primary organizer of these regattas, the Pasquotank River Yacht Club, coordinated with a multitude of local organizations and individuals to make them as successful as they were. Assistance from the US Coast Guard was paramount as to the implementation of these races as well as the safety of all who attended. Officials from the American Power Boat Association (APBA) were on hand to conduct and record the several measured and timed trials over the course of the two-day competition. Then there was the city itself, the businesses, civic groups, governmental departments, and private citizens, who helped promote the International Cup Regattas. The 1956 regatta welcomed over 50,000 visitors to Elizabeth City during the last week in September. Well over a dozen competing classes totaling around 120 entries were registered in that year's races, which included parades, fish fries, art shows, and beauty pageants, among several other attractions.

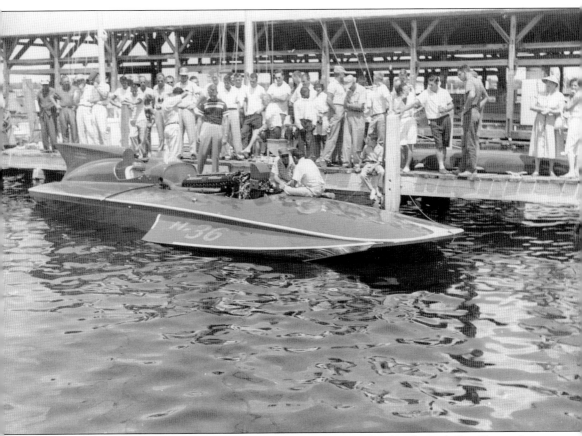

The image above depicts George Simon's *Miss U.S. IV* (U-36) moored at the Elizabeth City Shipyard during the 1957 International Cup Regatta. Simon's hydroplane was the only entry to compete in the Unlimited class that year due to a scheduling conflict with another APBA sanctioned race in Madison, Indiana. Thus, *Miss U.S. IV* won the 1957 International Cup by default after driver Bob Rowland of South Norfolk, Virginia, made one 15-lap heat on the course and was awarded the perpetual trophy afterwards. Her sister hydroplane, *Miss U.S. I*, took home the International Cup title in 1956. Another highlight of the 1957 regatta was the new world record set for the mile trials in the F-Service Runabout class. Jim Venner of Plainfield, New Jersey, drove his inboard entry, *Too Much* (M-12), to a record speed of 63.214 miles per hour during the final day of races.

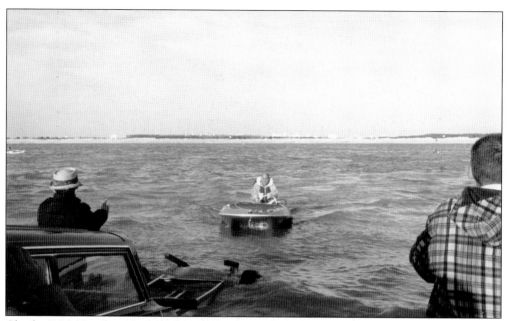

Charles F. McNaughton Jr. drove his way into powerboat racing history at the 1963 International Cup Regatta by setting a new speed record in the E-Pleasure Craft class. On Saturday, September 28, McNaughton drove a record speed of 42.168 miles per hour in his entry, *White Tail* (F-64). Powering this agile outboard speedster was a 1963 four-cylinder Mercury 650 motor capable of producing 65 horsepower. These new Mercury outboard models were finished in a phantom black paint scheme and offset in chrome trim. McNaughton's *White Tail* completed two straightaway runs in 52.8 seconds and 53.3 seconds, respectively. He was awarded a certificate, currently held in the Museum of the Albemarle's collection, by the American Power Boat Association.

The year 1958 was the last big one for the Unlimited-class hydroplanes competing at the International Cup Regatta. However, that year also saw the first APBA–sanctioned national championships held in Elizabeth City. In 1959, the Harbor of Hospitality hosted the national championship races for the E and F-Service Runabout classes. Throughout the 1960s, the smaller hydroplane and runabout classes would take center stage on the Pasquotank River. During the 12th annual International Cup Regatta, over 60 entries raced in 10 outboard events on Saturday, October 2, 1965. Camden County resident and Pasquotank River Yacht Club's own Floid E. Owens took first-place finishes in two events. He won both the class A Utility Runabout and the class C Stock Hydro races with an average speed of 50.50 miles per hour and 54.41 miles per hour, respectively. Miles L. Clark was honored on the cover of the 12th annual International Cup Regatta program (above), as he had passed away on May 30, 1965. The regatta that year was dedicated to "Uncle Miles," who was a tireless champion and promoter of Elizabeth City and its endeavors.

From the mid-1950s onwards, Elizabeth City's Moth Boat Regattas gradually waned as fewer competitive races were being held on the river. By 1972, the old International Moth Class Association, whose centralized organization in the United States had been eliminated, evolved into independent national bodies with equal partnership. It was only years later that a revival to bring back the "classic" Moth boat eventually led to the start of a new era of Moth Boat Regattas in 1989. The Museum of the Albemarle played no small part in organizing these regattas during the following decade and into the 21st century. Pictured above are Museum of the Albemarle staffers, from left to right, Lynette Sawyer, Denise Irby, Candance Perry, and Mary Tirak at the 1989 regatta. Below is a view of the competing entries at the 1996 Moth Boat Regatta. (Above, courtesy of Lynette Sawyer.)

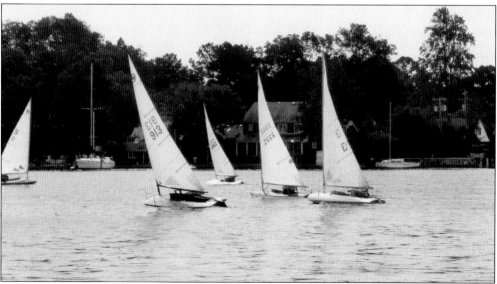

While the later regattas of the 1990s and 2000s were not the grand exhibitions they once were, these races still garnered support from many in the Moth boat sailing community. Older enthusiasts and spectators, who appreciated the history and heritage of the original craft, helped inspire a new generation of Moth boat sailors and supporters. In the image above, Pasquotank River Yacht Club members, from left to right, Bob Carson, Wayne Mathews, and Lloyd E. Griffin III attend an awards banquet at the 1997 Moth Boat Regatta. In addition to the Moth boat, other small sailing craft have often raced on the Pasquotank River, including the Force 5. Below is a picture from the 1998 national championship with several Force 5 entries racing in front of the Weeksville Dirigible Hanger. (Below, courtesy of Wayne Mathews.)

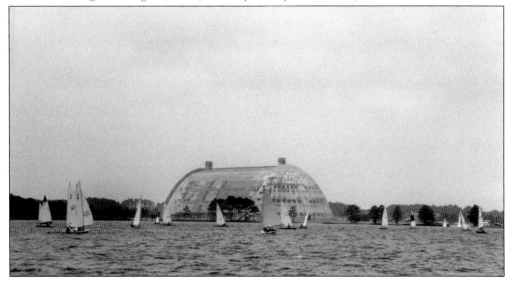

DISCOVER THOUSANDS OF LOCAL HISTORY BOOKS
FEATURING MILLIONS OF VINTAGE IMAGES

Arcadia Publishing, the leading local history publisher in the United States, is committed to making history accessible and meaningful through publishing books that celebrate and preserve the heritage of America's people and places.

Find more books like this at
www.arcadiapublishing.com

Search for your hometown history, your old stomping grounds, and even your favorite sports team.

Consistent with our mission to preserve history on a local level, this book was printed in South Carolina on American-made paper and manufactured entirely in the United States. Products carrying the accredited Forest Stewardship Council (FSC) label are printed on 100 percent FSC-certified paper.